IMAGES of America
HIGHLAND PARK
SETTLEMENT TO THE 1920s

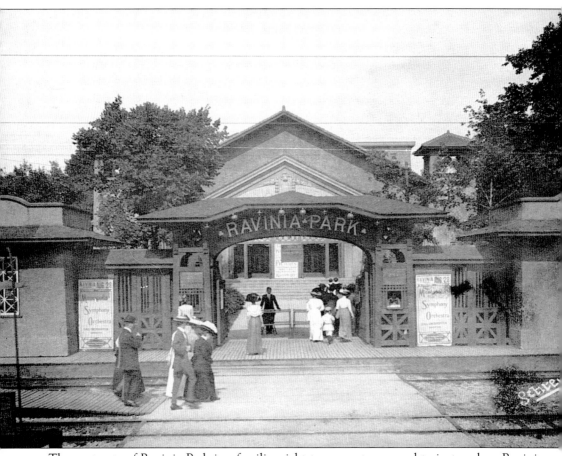

The west gate of Ravinia Park is a familiar sight to concertgoers and train travelers. Ravinia Park opened in the fall of 1904 as an amusement park to promote travel on the Chicago and Milwaukee Electric Railway. Its entertainments featured plays, dances, and concerts. The summer outdoor concerts were especially popular.

On the cover: Fairview subdivision was created in 1895 by Chicago lawyer Marcus Hitch, who planned to develop it into 171 lots. James A. Franklin was contracted to build 15,000 feet of plank sidewalk, William E. Cummings for street grading and water mains, and William Obee for the concrete sidewalks. However, before development got under way, Curtis N. Kimball purchased most of the subdivision for his country estate, Ridgewood. (Courtesy of the Highland Park Historical Society.)

IMAGES of America
HIGHLAND PARK
SETTLEMENT TO THE 1920S

Julia Johnas

Copyright © 2007 by Julia Johnas
ISBN 978-0-7385-5101-2

Published by Arcadia Publishing
Charleston SC, Chicago IL, Portsmouth NH, San Francisco CA

Printed in the United States of America

Library of Congress Catalog Card Number: 2007926220

For all general information contact Arcadia Publishing at:
Telephone 843-853-2070
Fax 843-853-0044
E-mail sales@arcadiapublishing.com
For customer service and orders:
Toll-Free 1-888-313-2665

Visit us on the Internet at www.arcadiapublishing.com

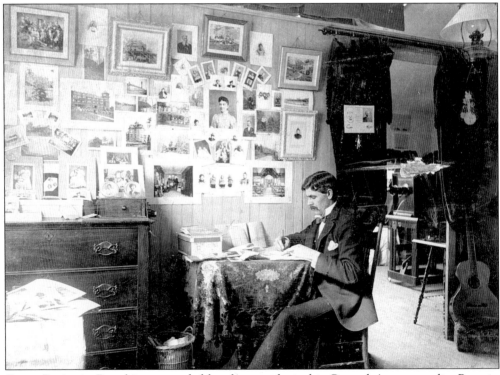

Orson Benjamin Brand is surrounded by photographs in his Central Avenue studio. Born in 1867, he came to Highland Park with his parents at the age of 15 and opened Highland Park's first photographic studio in 1892. Many of the images in this book are the result of his work.

Contents

Acknowledgments 6

Introduction 7

1. Pioneers 9

2. Picturesque Highland Park 33

3. Progress in a New Century 61

4. Portraits 113

Bibliography 126

Index 127

ACKNOWLEDGMENTS

This book would not have been possible without the treasured collections of the Highland Park Historical Society and the Highland Park Public Library. It has been a privilege and a pleasure to explore such a rich archive of community history. I am grateful to the society and the library for generously making their materials available to me.

For their essential help and encouragement, my deepest thanks to the following people: Fred Orkin, president of the Highland Park Historical Society, for his enthusiastic support; Kathy Leable, executive director of the society, for trusting me with precious photographs, for her research assistance, and especially for staying after hours at the museum whenever I got "lost in time"; Beth Nickels-Wisdom for proofreading and gently correcting the text; Al Ramirez for his computer assistance; Jeff Ruetsche for his guidance and editorial advice; Larry Shure for helping to identify images; Margaret Smith for creating an index to the Highland Park newspapers; and Sam Wengroff for transforming slides (and a map or two) into digital images.

Many others have influenced the development of this book. I have benefited greatly from their knowledge, stories, and recommendations. Every effort has been made to present an accurate history of Highland Park. I regret any errors and am solely responsible for them.

INTRODUCTION

In 1867, 10 men purchased Highland Park for $39,198.70. They were the original stockholders of the newly chartered Highland Park Building Company: Harvey B. Hurd, an attorney and the largest stockholder; Rev. William W. Everts, a distinguished Baptist clergyman; Edwin Haskins, a prominent wholesale salt dealer; Cornelius R. Field, cashier of the First National Bank of Chicago; Judge Henry Booth; Jesse O. Norton, district attorney of Cook County; John H. Wrenn and Edward L. Brewster, leading brokers; and Nehemiah Hawkins and his brother Frank P. Hawkins, who served as general agent and manager. They purchased 1,200 acres east of the Chicago and Milwaukee Railroad line from Walker Avenue south to Ravine Drive.

An earlier attempt to develop this land was made by another group of real estate investors, the Port Clinton Land Company. Following construction of the Chicago and Milwaukee Railroad, a depot was established at Highland Park and a plat, extending south to Central Avenue, was laid out in 1856. Walter S. Gurnee, president of the railroad and a stockholder in the land company, gave Highland Park its name. He hoped to profit through development of land adjacent to the railroad line, but economic turmoil and the onset of the Civil War halted development. Gurnee bought up the holdings of fellow stockholders and sold them to the Highland Park Building Company.

West of the railroad, Highland Park's earliest settlers had established farms in the Skokie valley. Following the removal of the Potawatomi in 1836, Lake County was opened for nonnative settlement. A military road, built in 1833, from Fort Dearborn to Fort Howard in Green Bay, Wisconsin, ran along a ridge between Lake Michigan and the Skokie valley. Early settlers began arriving by this narrow wagon trail, the Green Bay Road, in the early 1840s. In what would later be the southern portion of Fort Sheridan, the village of St. Johns was laid out in June 1847. It went out of existence, owing to litigation over the property title, and in April 1876, the plat of the town was vacated. Another village, Port Clinton, was laid out just south of St. Johns in January 1850 by Jacob Clinton Bloom. A year later, the thriving community had 30 buildings and a school. Lumber products and brick making were the main industries. A cholera epidemic in 1854, which caused many deaths, and the location of the railroad station in Highland Park rather than Port Clinton hindered further progress. Port Clinton was eventually absorbed into Highland Park.

To guarantee the success of its real estate venture, the Highland Park Building Company set out at once to make improvements. A brick hotel on the southwest corner of Central Avenue and First Street was renovated. A pier was constructed to receive excursion boats and for unloading lumber. A commercial building (later known as McDonald's store) with a second-story assembly hall was built on the northeast corner of Central and St. Johns Avenues. Model homes were constructed on Belle Avenue to attract residents.

On March 11, 1869, the Illinois legislature granted a charter to the City of Highland Park. The city was laid out in four wards, and a mayor and eight aldermen were elected on April 13. Frank P. Hawkins was chosen as mayor.

Early advertisements of the building company boasted "good schools, good churches, and good society," and steps were taken to ensure the truthfulness of that claim. Incorporation authorized the building company to enact an ordinance prohibiting the public sale or consumption of

liquor and to close the eight saloons that were in operation in the community. Two days after its election, the city council appointed a committee on schools and in June 1869 accepted a proposition from the building company to construct the Port Clinton Avenue School. The Highland Park Religious Association, a nondenominational organization, was formed in October 1869 and met in McDonald's hall. Rev. George L. Wrenn conducted services. After the Baptists, Presbyterians, and Episcopalians established separate churches, the association was dissolved in March 1874. Catholics had been worshipping at St. Mary's in the Woods church on South Green Bay Road since 1846.

In 1871–1872, a new plat of Highland Park was made that extended the southern border to Ravinia. Under the direction of landscape gardener Horace W. S. Cleveland and civil engineer William M. R. French, the plat took advantage of the natural beauty of the bluffs, woodland, and ravines. Not adopting the straight rectangular street plan of the northern portion of Highland Park, Cleveland and French followed the natural topography of the ravines to design the curving avenues of Ravine Drive, Waverly Avenue, Highland Avenue (later Sheridan Road), Lincoln Avenue, South Linden Avenue, and Cedar Avenue. Lakeview Road, running along the bluff from Beech Street to Cedar Avenue, was designed to reveal breathtaking views of Lake Michigan. The artistry of their work created a lasting image of Highland Park as a place of unspoiled beauty where tastefully designed residences adorned the landscape.

By 1872, 10 daily trains made stops at Highland Park. A number of fine residences, several businesses, and a beautiful resort hotel had been built before the financial panic of 1873 slowed the improvement and growth of the city and caused the disbanding of the Highland Park Building Company. The stockholders divided the remaining unsold real estate. By the mid-1880s, Highland Park began to regain its economic strength, and civic, business, and residential improvements once again moved forward. Its 1880 population of 1,154 nearly doubled to 2,163 by 1890. Economic expansion throughout the country created a wealthy leisure class encouraged to seek the benefits of a rural lifestyle. The healthy, tranquil surroundings of a country home were the perfect antidote to the crowded, noisy, and dirty urban environment. Highland Park was ideally situated to provide the cure, and wealthy Chicagoans were soon taking advantage of the relatively cheap real estate to build summer homes.

About two miles south of Highland Park, the community of Ravinia was laid out in April 1872 on approximately 600 acres. The original developers included Walter S. Gurnee, Benjamin F. Jacobs, Rev. William W. Everts, Richard R. Donnelley, and Marcus A. Farwell. The community was planned as a Baptist settlement, and streets were named after Baptist leaders, Roger Williams, Miles Bronson, Adonirum Judson, William Carey, Luther Rice, Eugenio Kincaid, and William Dean. Like Cleveland and French's Highland Park design, Ravinia's streets conformed to the natural topography and the irregular course of the ravines. Ravinia was annexed to Highland Park in 1899 but continued to maintain a distinct identity. In the early decades of the 20th century, Ravinia resembled an artists' colony because of the number of artists, writers, musicians, and architects who were residents.

The steady growth of Highland Park accelerated during the 1920s. A community of 6,167 in 1920 welcomed an additional 6,036 residents by 1930. As land values increased, many of the farms and large estates were subdivided. Among the new subdivisions were Deere Park, Hill and Stone's Shore Crest, Ravinia Highlands, Krenn and Dato's Highland Park Gardens, and Sunset Terrace. More than six square miles were annexed to the city in 1924, and construction of the Skokie valley route of the Chicago North Shore and Milwaukee Railroad in 1926 stimulated development in western Highland Park. New homes were constructed around the Briergate, Woodridge, and Highmoor train stations. Substantial commercial structures replaced small shops in the business district. The intermediate building of Elm Place School, and the Ravinia, Braeside, and Green Bay schools were constructed to handle the burgeoning student population. Quiet country lanes were paved and rustic bridges converted to concrete. By the time its earliest promoter and first mayor, Frank P. Hawkins, died in 1935, Highland Park had fulfilled his vision of progress and prosperity.

One
PIONEERS

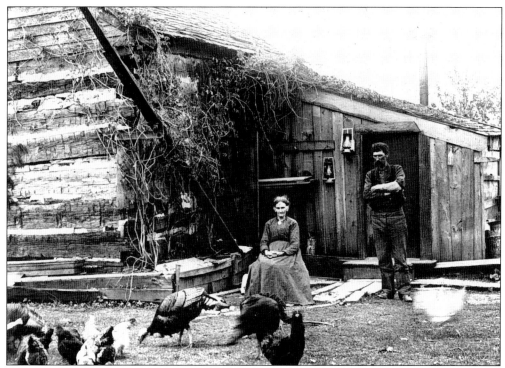

Early settlers, primarily German and Irish immigrants, arrived in the 1840s and established farms in the open countryside west of Green Bay Road. This unidentified couple raised turkeys and chickens. The milk can at the far right in the photograph indicates that they also owned cows. Their home was constructed of square-cut logs and was typical for pioneer settlers in an area with plentiful wood.

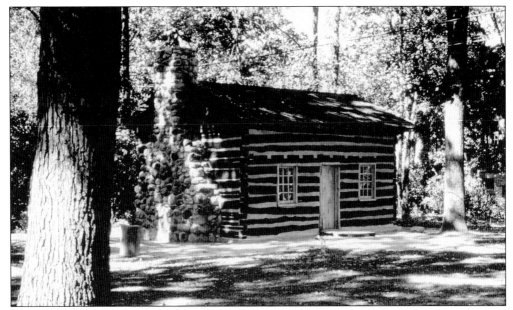

Francis Stupey built this house in 1847 when he arrived from Germany with wife Margaret and daughter Catherine. In 1875, he built another house on his farm to accommodate a family that eventually numbered 14 children. In 1896, the farm was sold and became the grounds of the Exmoor Country Club. The first house served as a caddie shack until it was donated to the Highland Park Historical Society in 1969.

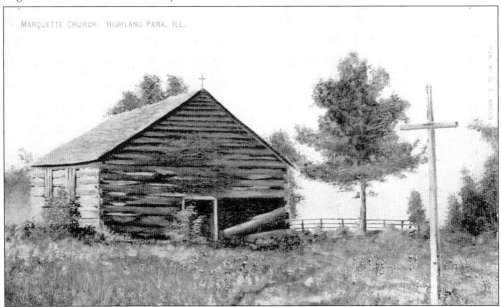

In 1846, a log church was constructed on South Green Bay Road by James Mooney, Andre Xavier Loesch, Sebastian Stipe, Thomas McCraren, and other Catholic settlers. A wooden cross was added when it was dedicated as St. Mary's in the Woods on August 15, 1853. The church was used until 1872, later falling into disrepair. In March 1894, it was destroyed when the roof caved in from heavy snow. A myth developed that the church had been constructed by Père Jacques Marquette.

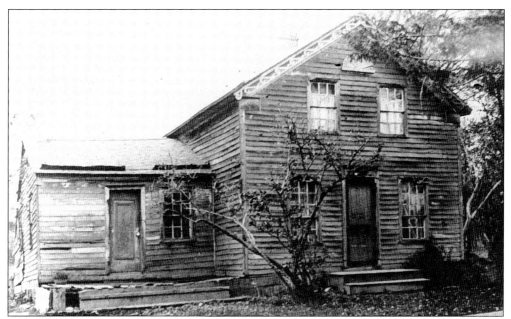

The North Green Bay Road home of herb doctor Peter Mowers was one of the first frame houses in the area. Built in 1852, it was later occupied by his daughter Mary Ann and her husband, Alfred St. Peter. Their sons Orville and Sol operated the Reliable Laundry. Mowers owned a brickyard in the village of St. Johns. In 1851, the *Waukegan Weekly Gazette* reported that Mowers would make 400,000 bricks that season. After St. Johns ceased to exist, the land became part of Fort Sheridan, and the buff-colored clay was used to make bricks for building construction at the fort.

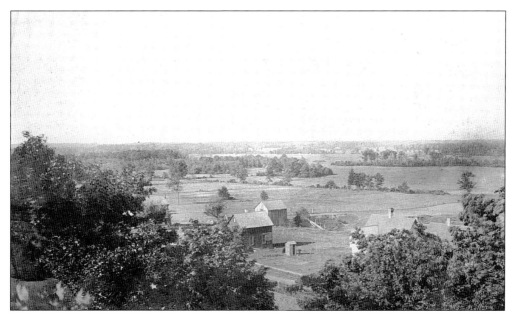

A view to the southwest from the Green Bay Road ridge shows the farmland of the Skokie valley. Farmers found a ready local market for food crops such as milk, meat, butter, eggs, fruit, and vegetables.

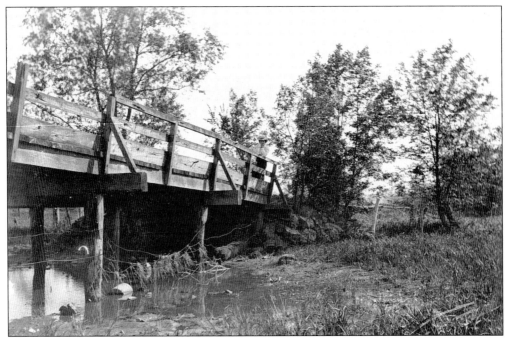

The first east–west road from Highland Park was Deerfield Road, begun in 1854 or 1855. A wooden bridge was constructed where the road crossed the Skokie River. The slow-moving river was bordered by marshy low ground that attracted migrating and year-round birds.

The Duffys were among the earliest settlers in the area. James Duffy purchased 80 acres in 1844. This December 6, 1890, photograph shows the home of Bridget Duffy on the north side of Laurel Avenue at McGovern Street. Bridget's husband, William, died in 1888, leaving her a 39-year-old widow with eight sons and a daughter.

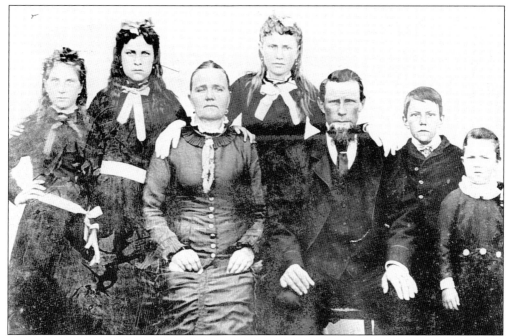

Sebastian Stipe and his wife, Mary, were also among the earliest settlers. Mary was the daughter of Herman Joseph Koller, who purchased 80 acres in 1845. The Stipes' two oldest daughters are not identified in this 1880s family portrait. From left to right are Christina, Elizabeth (or Rosa), Mary, Rosa (or Elizabeth), Sebastian, Martin, and Joseph.

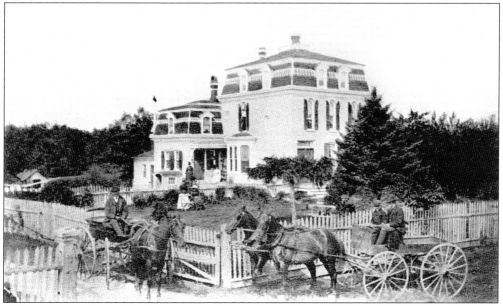

Shortly after the Civil War, Sebastian and Mary Stipe took over Mary's father's farm on Clavey Road. Their home was located on Green Bay Road between Edgewood and Clavey Roads. Photographed in 1882, the house was built around 1880 by Joseph Rioux, owner of the North Shore Laundry, and was demolished after Sebastian's death in 1924 when the farm was sold to the Northmoor Country Club.

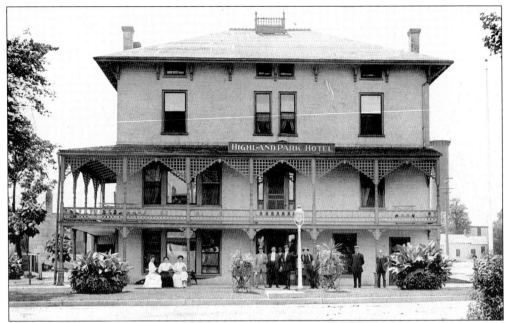

Highland Park Hotel was built on the southwest corner of Central Avenue and First Street in 1852 by James W. Ayres. In 1868, Samuel S. Streeter took over its operation for 10 years. His brother-in-law Harvey Green was the next owner when it was known as Central Hotel. Highland Park resident Sarah Loesch recalled working there as a "baby pusher" for $1 per day in the 1880s. Young girls were hired to take the children of hotel guests for an "airing," pushing them to the lake in perambulators.

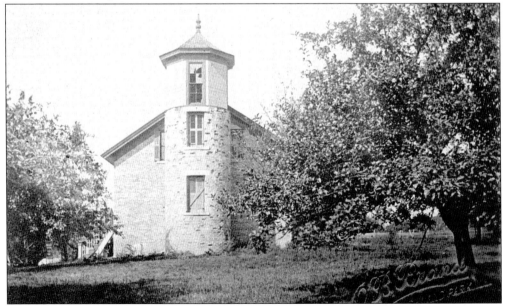

On August 3, 1854, the federal government authorized $5,000 to build a lighthouse at Port Clinton. Constructed on a bluff north of Broadway Avenue in 1856, it was 22 feet high and 70 feet above lake level. Its fixed light was visible for six miles. Owen Monaghan was keeper until 1860 when the government discontinued its use. It was demolished around 1900.

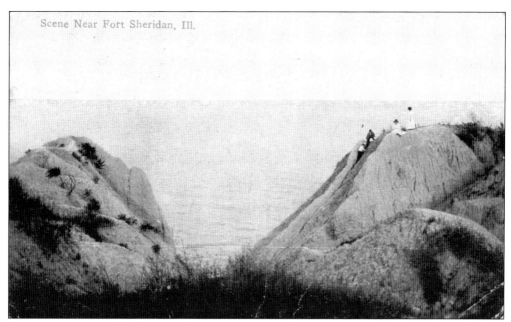

The topography of Highland Park was a novel landscape to many early visitors. Towering bluffs, ravines, oak forests, and sandy beaches captivated sightseers. The area's natural beauty and the benefits of a healthy environment were touted in Highland Park Building Company advertisements to entice prospective residents.

Frank P. Hawkins, agent and manager for the Highland Park Building Company, built his own home (designed by William W. Boyington) in 1867 on Laurel Avenue just east of St. Johns Avenue. The plat of Highland Park was laid out under his direction with careful attention to creating picturesque views. To safeguard the city's natural beauty, in 1870 he advocated an ordinance that protected shade trees and outlawed their use for hitching horses.

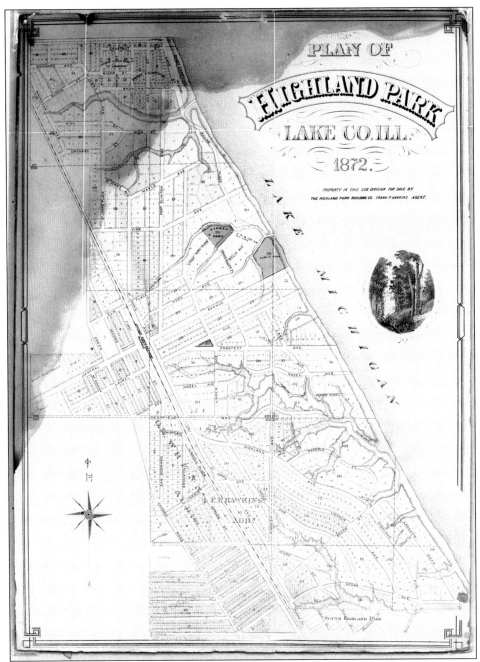

The first plat of Highland Park extended south to Ravine Drive and was laid out according to the traditional method of rectangular blocks. In 1871, the Highland Park Building Company hired landscape architects Horace W. S. Cleveland and William M. R. French to create this plat for a southern addition to the city. Cleveland advocated a design that "followed the natural shape of the ground." Two years later, Cleveland published *Landscape Architecture as Applied to the Wants of the West* and clearly had Highland Park in mind when he spoke of arranging suburban additions to preserve the "picturesque and attractive character" of bluffs and ravines, which he maintained could not be done "by a system of rectangles."

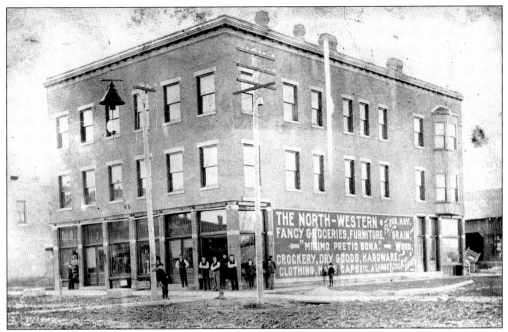

Moses Moses opened the North-Western store on April 27, 1868, at the northwest corner of Central Avenue and First Street. The building pictured here was constructed after the original store was destroyed by fire in October 1892. In 1890, streetlights were installed at the 25 most important intersections in Highland Park.

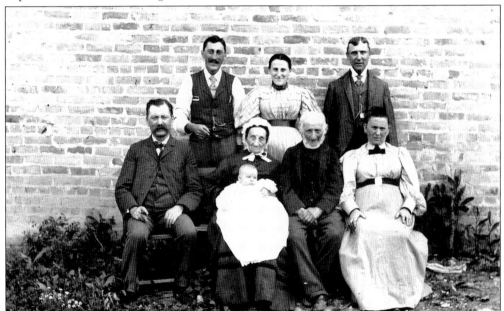

Moses Moses and his family pose for this 1896 portrait. Pictured are, from left to right, (first row) Moses, Yetta and Moses Loeb (Fanny's parents) with baby Lee (son of Bertha and Herman), and Fanny; (second row) son Alfred, daughter Bertha, and Bertha's husband, Herman Loeb. Bertha was one of two members of the first graduating class (1887) of Deerfield Township High School. After Moses died in 1911, Alfred took over the North-Western store.

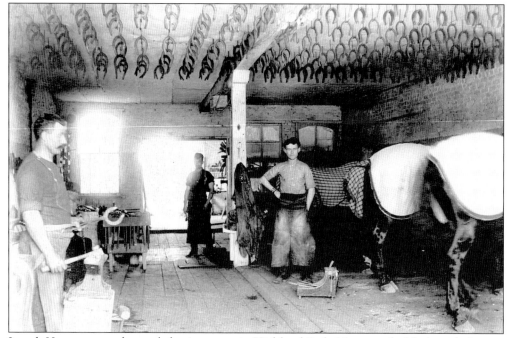

Joseph Happ was another early businessman in Highland Park. He opened a blacksmith shop in 1867. After he died in 1908, the business was operated by his son John, pictured at left around 1910. John's son, Harry (right), also worked as a blacksmith.

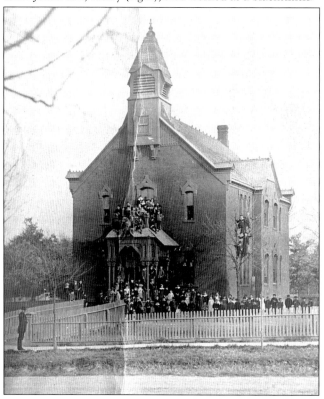

Two months after its incorporation, Highland Park set out to establish a public school. Built in 1870 at the corner of Port Clinton (later Sheridan Road) and Elm Avenues by the Highland Park Building Company, the Port Clinton Avenue School had two large rooms on the first floor with a hall in between, one large room upstairs, a principal's office, and an alcove for the bell. A picket fence encloses the school yard in this 1880s photograph.

Port Clinton Avenue School teachers in this June 21, 1880, photograph are, from left to right, Belle Mackie, Theresa Elliott, O. M. Kyle (principal from 1877 to 1883), and Bertha Baker.

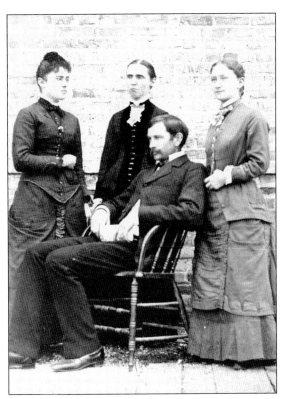

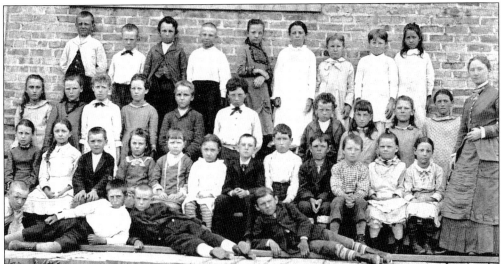

Bertha Baker's students were photographed on June 21, 1880. From left to right are (first row) Fred Crosby, Everts Wrenn, Charlie Barnum, and Charlie Unbehaun; (second row) Blanche Bishop, Clara Wait, John C. Duffy, Dagluner (?) Haanshuns, Stella Finney, Celia Wait, Arthur St. Peter, Eddie Stokes, Frank Sheahen, Willie Johnson, Sarah Sheahen, Lulu Elvey, and Bertha Baker; (third row) Eva Inman, Ada Alford, Neva Sommers, Alice Connerton, Harry Stuart, Herbert Lauder, Willie Smith, Belle Cray, Sarah Unbehaun, and Anna Curley; (fourth row) Henry Hiebler, Lee Sommers, George Smith, Sammie Barnum, Alice Skidmore, Sarah Duggan, Helen Starrett, Kathie Starrett, and Ella Curley.

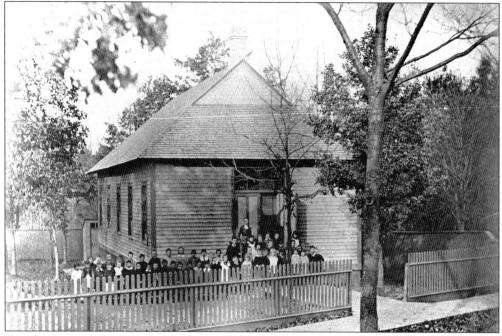

To relieve crowded conditions at the Port Clinton Avenue School, a small frame classroom building was constructed in 1883 on the east side of the school grounds. This building was sold in the early 1890s for $260 and relocated to Sheridan Road just north of Central Avenue. It housed the Highland Park Public Library from 1900 to 1905.

Fairview School was built in 1886 at the corner of Glencoe and Lincoln Avenues for students in south Highland Park. William W. Boyington was the architect for this two-room frame building. It was replaced in 1909 by Lincoln School.

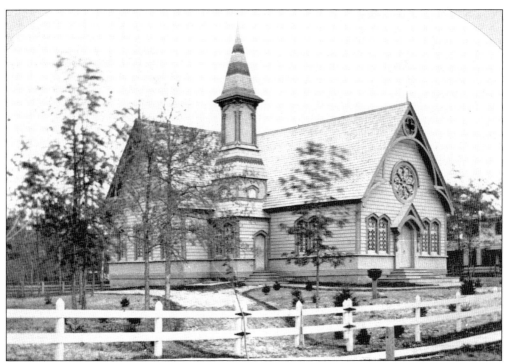

A photograph of the Baptist church, taken in June 1874, reveals a Gothic Revival building with decorative bargeboards in the gables and a multicolored steeple. It was located on Laurel Avenue between St. Johns and Linden Avenues. Prior to its construction in 1872, congregants met in the hall above McDonald's store at the corner of St. Johns and Central Avenues. Rev. George L. Wrenn served as pastor until 1879. Jonas Steers, pictured inside the church in June 1888, was an original member of the congregation, superintendent of the Sunday school for 13 years, and a deacon for 33 years.

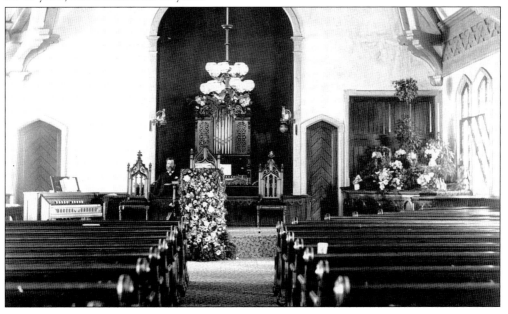

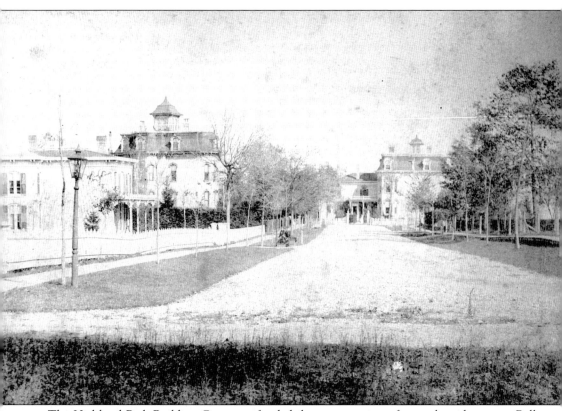

The Highland Park Building Company funded the construction of several residences on Belle Avenue that served as model homes. The street was named after Frank P. Hawkins's daughter Celia Belle. Jonas Steers, who lived on the street, was the contractor for all but one of the homes, including the Second Empire house at middle left, which he sold in March 1874 to Frederick Fischer of Murdoch and Fischer, wholesale grocers. A butcher by trade, Steers had pursued his interest in real estate in Chicago where he built seven houses. After coming to Highland Park in October 1868, he operated a meat market but closed it in 1887 to work exclusively in real estate development. Streetlamps were installed in Highland Park in 1875. Oil was provided by the city, and residents were responsible for lighting and extinguishing the lamps each day. In the 1880s, that task was assigned to policemen. Hitching posts and carriage steps were common features of the streetscape at the time.

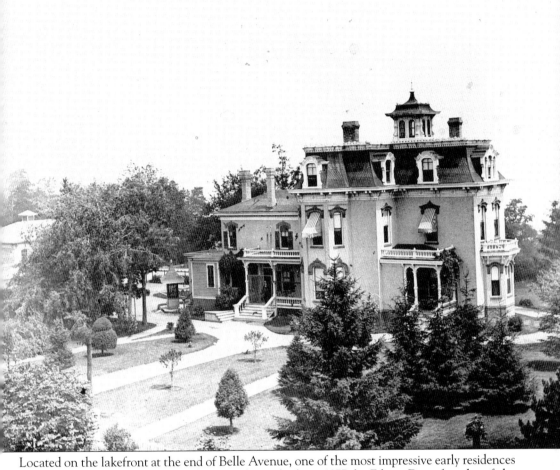

Located on the lakefront at the end of Belle Avenue, one of the most impressive early residences of Highland Park was the Second Empire home built in 1877 for Edwin Dyer, founder of the Chicago Foundry Company. The four-acre estate was purchased by Dyer's son-in-law, William W. Flinn, in 1880 and sold by him in December 1891 to R. W. Rathborne of the Chicago Board of Trade for $20,000. At the time of this 1896 photograph, it was known as Fancy Hill and was owned by Augustus Scott Campbell, for several years U.S. marshal of the Northern District of Illinois and director of the Bank of Illinois. The carefully manicured grounds, walkways, and ornamental plantings were characteristic of Victorian-era country estates. An 1891 description of the property noted, "Forest trees beautify the scene which has also been improved by artistic landscape gardening, making [it] one of the most attractive and romantically situated homes to be found in the suburbs of Chicago." For another view, see page 27.

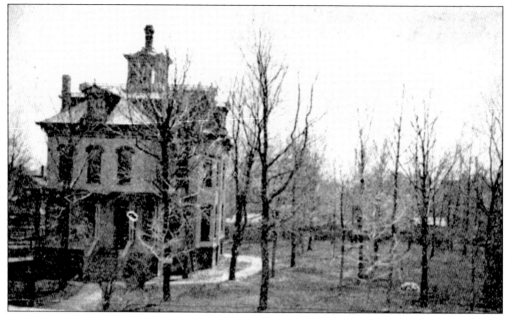

This November 1895 photograph shows the John T. Raffen house in Ravinia. Raffen was described as "one of the heavy capitalists who make Chicago their home." He was a partner in the iron manufacturing firm of Clark, Raffen and Company. His house was used initially as a summer residence. Raffen's daughter Marie and Bertha Moses comprised the first graduating class (1887) of Deerfield Township High School.

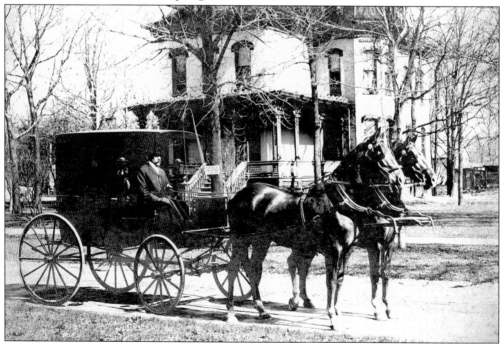

A coachman waits outside the Raffen house. The property is listed for sale in this photograph. The real estate agent was Henry K. Coale, a noted Highland Park realtor. Dr. Frank M. Ingalls purchased the house and opened it as the Highland Hotel on May 15, 1898.

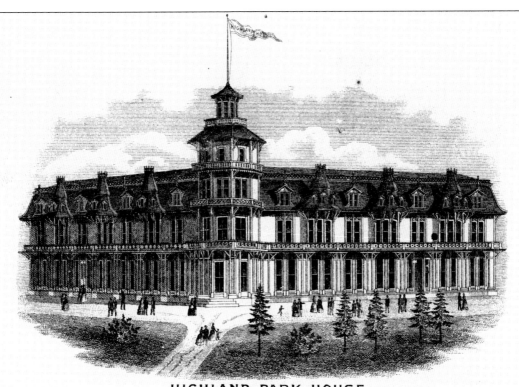

Built by the Highland Park Building Company at St. Johns Avenue and Ravine Drive, Highland Park House opened on July 8, 1873, as a resort hotel for summer guests. It was designed by William W. Boyington and situated on five acres providing areas for archery, lawn tennis, and croquet. Each of its 125 rooms had a door that led to an outside veranda or balcony. Additionally guests could enjoy a view of Lake Michigan and the country for miles around from a rooftop promenade. The calling card pictured here is inscribed on the back, "Will Mr. Hammond oblige me by giving the bearer the promised shot pouch and powder flask. CC Keeler Aug. 1, '73." In 1876, Highland Park House was transferred to Prof. Edward P. Weston to serve as an educational institution for young ladies during the winter. It continued to operate as a hotel during summer. Known as Highland Hall after the transfer, the building was purchased in May 1888 for the Northwestern Military Academy. It was destroyed by fire on November 1, 1888.

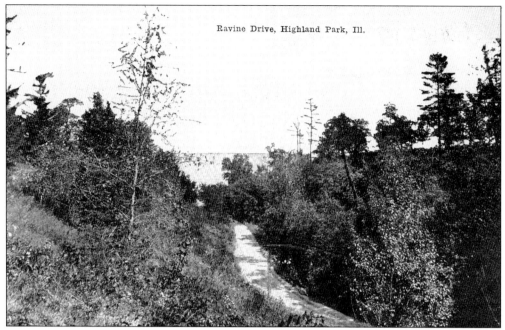

The four-mile Ravine Drive was considered one of the most scenic drives in Highland Park. It extended from Highland Park House to Lake Michigan. An 1877 book described it, noting that Highland Park House was "about fifteen minutes' walk from the lake shore, in the midst of picturesque scenery and surrounded by the residences of cultured and wealthy families, quiet and healthful."

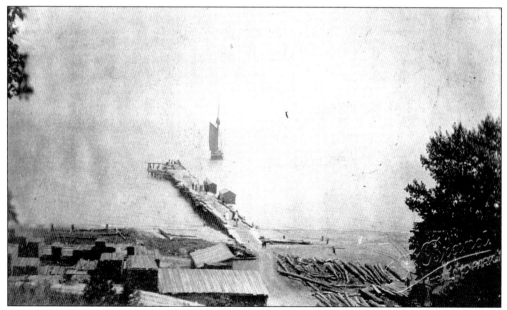

Archibald W. Fletcher's pier, at the foot of Park Avenue, was a local landmark for many years. Fletcher came to Highland Park in the spring of 1883, built a pier from which to operate his coal business, and a year later established a thriving lumberyard at the same location.

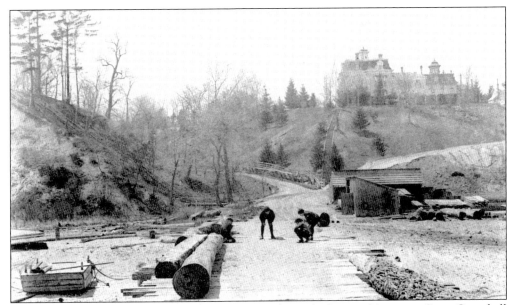

This 1890s view from Archibald W. Fletcher's pier shows the home of Augustus Scott Campbell with a flight of stairs descending the bluff. The steps at left led from the Central Avenue park. In 1892, Charles H. Baker joined Fletcher's lumber business, and John T. Raffen took over Fletcher's interest the following year. The business, known as Raffen and Baker, was awarded the lumber contract for the construction of Fort Sheridan.

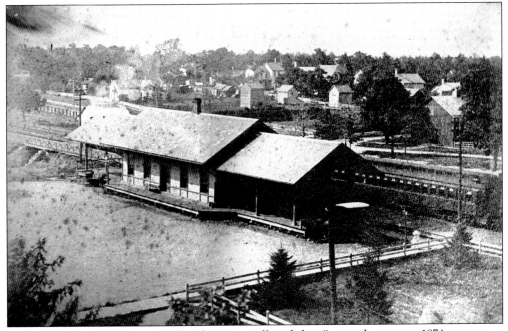

The depot building in Highland Park was "small and dirty" according to an 1874 newspaper article. Shortly afterward, it was destroyed by fire and replaced in 1875 by this station on the east side of the tracks on St. Johns Avenue between Laurel and Central Avenues. In 1899, this station was replaced in the same location by a brick structure. This view looks to the southwest from Central Avenue.

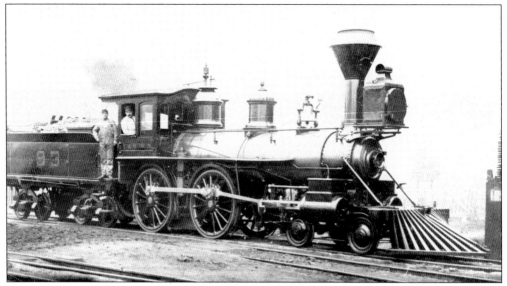

William Moroney was the engineer of the Chicago and Milwaukee Railroad's Highland Park train when this photograph was taken in 1881. His fireman, standing outside the cab, was Jack Farrell. The train left Highland Park around 8:00 a.m. each day and returned from Chicago at 9:00 p.m. The crew passed the intervening time at the roundhouse in Chicago. Moroney worked for the railroad for 42 years, retiring in 1909.

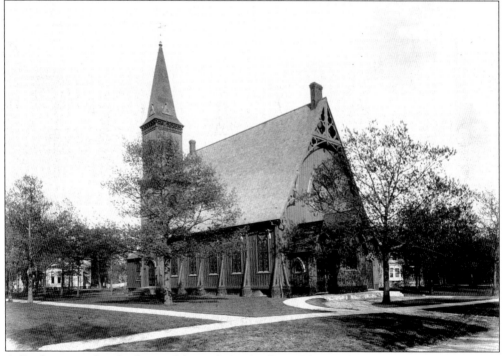

A Presbyterian church, designed by architect William W. Boyington in the Gothic Revival style, was constructed in 1874 at the southeast corner of Laurel and Linden Avenues. It was in this building, on December 29, 1874, that inventor Elisha Gray first demonstrated his electric telephone. This building was replaced in 1911 by a brick church at the same location.

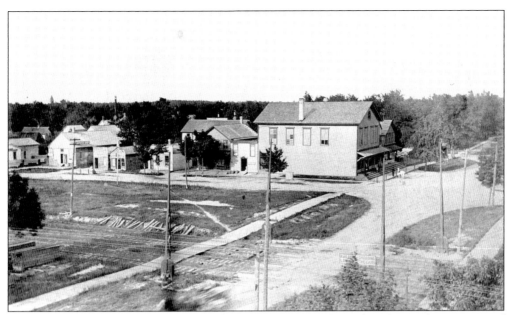

The center of Highland Park life revolved around a building located at the northeast corner of St. Johns and Central Avenues. Built by the Highland Park Building Company around 1869, the first floor contained a store operated by Asa K. Allen. The second floor had a small room used for council meetings and a large hall used for church services, dances and social entertainments, and as a classroom before the construction of the Port Clinton Avenue School. The building was purchased by James McDonald when he came to Highland Park in 1872. Albert Larson, who worked for McDonald for a year, remembered him as "an eccentric Scot who was scrupulously honest."

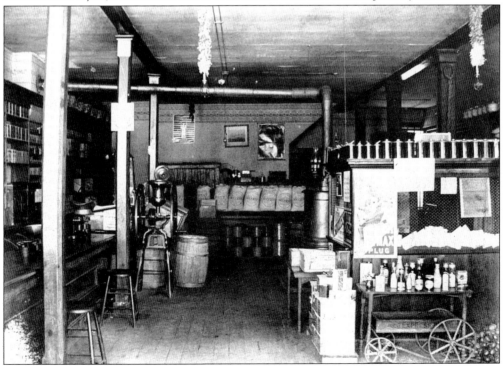

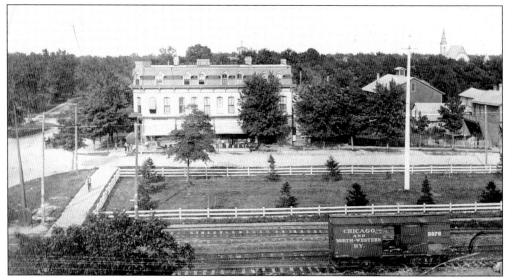

One of the first substantial commercial buildings in Highland Park was built in 1875 by Samuel S. Streeter, an insurance and real estate man. It was located on the southeast corner of St. Johns and Central Avenues. Among the businesses that occupied the building was the drugstore of George B. Cummings, which was taken over by Earl W. Gsell in 1909.

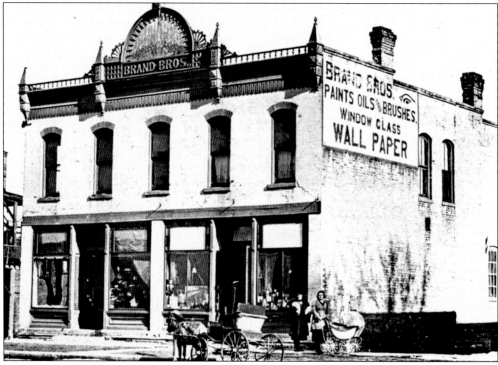

George L. and Silas P. Brand came to Highland Park in 1872. They constructed a paint store at the corner of Second Street and Central Avenue in 1882. The second floor of the store served as a location for church services and a school. Bethany Evangelical Church, organized in 1882, conducted services at Brand's for one year. A township high school, established in April 1887 with John T. Ray as the first principal, held classes at Brand's until 1900.

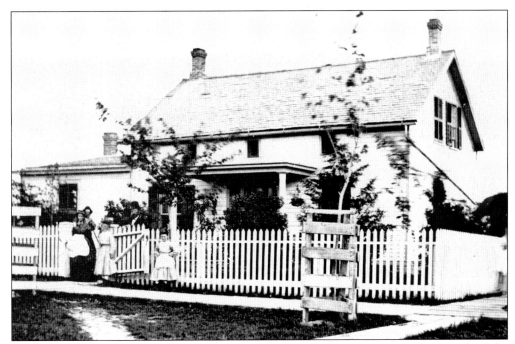

Mary Grace Hammond recorded "our house" on the back of this June 1874 photograph of the Charles Granville Hammond residence at the southwest corner of Green Bay Road and Central Avenue. Charles stands at the gate with his wife, Mary Rhees, and, from left, daughters Anna Rhees and Mary Grace.

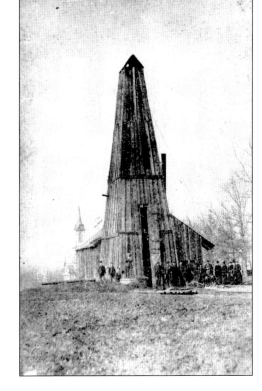

The city located an artesian well at the northeast corner of Green Bay Road and Central Avenue in September 1886. This view looks west, toward Bethany Evangelical Church, which had been erected at the northwest corner of Central Avenue and Green Bay Road in 1883.

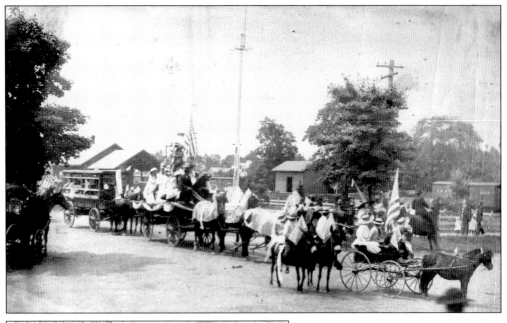

The annual Children's Day celebration began in 1879. All businesses closed and the day was set aside for children's pleasure. It began with a parade that wound its way from the depot to the Central Avenue park. Children were given tickets that could be used to purchase lemonade, ice cream, cakes, and other treats at a refreshment booth. Many families also brought basket lunches. Among the events were running races for boys, girls, men, and women; sack, wheelbarrow, potato, and three-legged races; and a cute baby contest—all with prizes. In 1886, the day concluded with a ball at Highland Hall. This 1886 photograph shows the parade at the intersection of St. Johns and Central Avenues.

Two
Picturesque Highland Park

"Those trails through the woods were lovely beyond description. At every bend a new adventure. The freshness of the air, the quiet, the birds and flowers, and through the trees, glimpses of the lake reflecting the sunlight," said Sidney Dealey Morris in a 1954 interview recalling the Highland Park of his 19th-century boyhood. Morris served as Highland Park building inspector from 1924 to 1946. This photograph is a view of Ravine Drive.

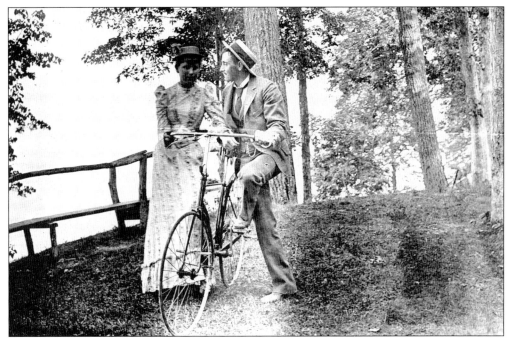

Orray Lee (right) and a companion were photographed on a bluff overlooking Lake Michigan. Shady groves and cool lake breezes were refreshing on hot summer days, and Highland Park's lakefront was a popular destination for local residents and Chicago visitors. On June 27, 1875, the *Chicago Daily Tribune* reported that during the past 10-day period "about 5,000 people have availed themselves of the park grounds on the lake bluff."

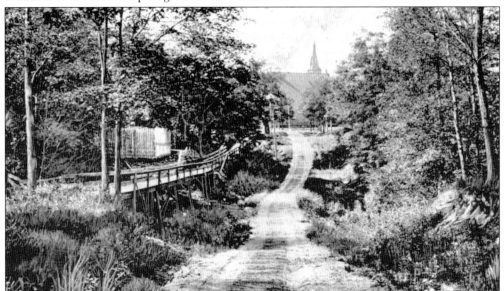

Linden Avenue, viewed looking north toward the Presbyterian church, was a narrow dirt lane through the ravine when this photograph was taken around 1890. A footbridge was provided for pedestrians. The ravine topography of Highland Park was both an asset and a liability. Ravines helped maintain the charming rustic setting but usually required bridges that residents found "taxing."

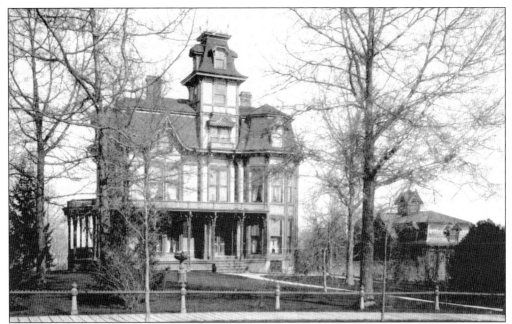

Chicago architect William W. Boyington built the elegant Second Empire–style residence (above) for himself in 1874. It was set on five acres on Port Clinton Avenue (later Sheridan Road). The property was part of the Everts-Boyington subdivision that had been purchased from the Highland Park Building Company in 1869 by Boyington and Rev. William W. Everts. Boyington sold the property for $15,000 in 1890 to William Arthur Alexander, founder of W. A. Alexander and Company, one of Chicago's largest insurance agencies. Alexander renovated it in the neoclassical style inspired by the architecture of the 1893 World's Columbian Exposition in Chicago. The circular porch pillars were from the state of Maine building and were equipped with lights. In 1894, Alexander and his bride, Maud Julia Greene, took up summer residence in the home, which they called Alter Meer (*meer* meaning "lake" in Dutch).

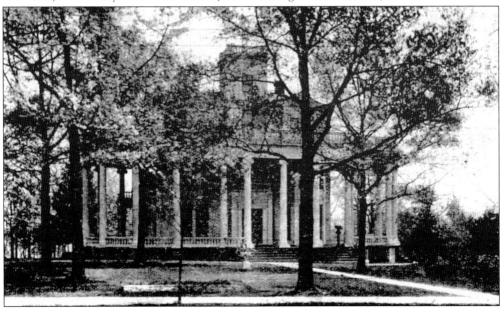

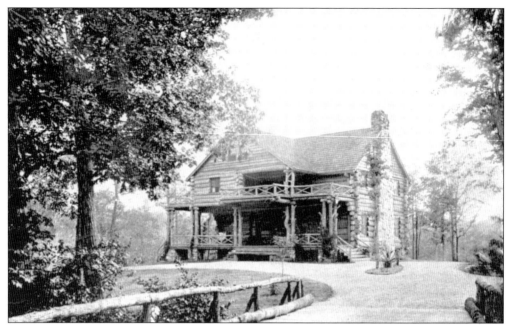

William W. Boyington was the architect for other Highland Park residents. He designed Ravine Lodge on a bluff overlooking Lake Michigan for Chicago lawyer Sylvester M. Millard. Known as the "log house," it was built with elm logs and remained in the Millard family until the 1990s.

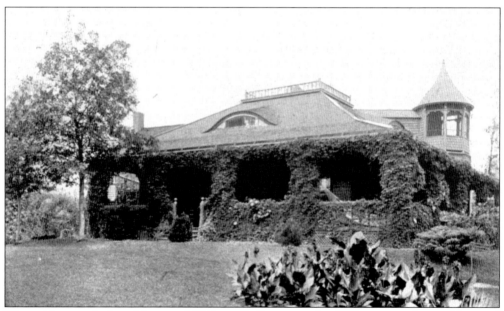

The red-brown clapboard house of William C. Egan was the 1889 version of a prefabricated home. Designed by Egan and built by the Harvey Lumber Company, it was brought in sections from Chicago and assembled on-site. A nationally known horticulturalist, Egan had retired from H. H. Shufeldt and Company in 1891 to devote his time to Egandale, his five-acre country estate. In 1912, *Country Life in America* called Egandale the "most famous small place in the Middle West."

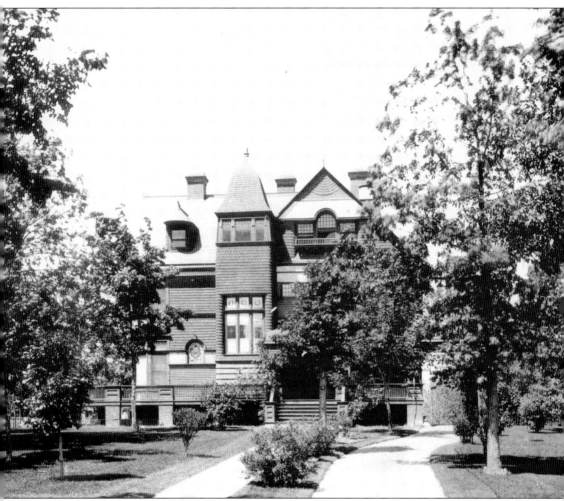

The *Chicago Daily Tribune* of February 9, 1889, reported, "Highland Park society met last evening at the new house of Mr. Eugene E. Prussing, Chicago lawyer . . . the house is a noteworthy addition to the architecture of the Park. It is of colonial design, with a broad front, sweeping curves, and an arched carriage-way . . . The library and dining-room are in sycamore. A high wainscoting of this wood in antique German patterns . . . runs around the long octagonal dining-room. Two columns of it, supported by broad bases and joined above by a beam, divide the main part of the room from the finely lighted bay in the end . . . The walls of the hallway, which is in oak, the walls of the library, and the ceiling of the dining-room are tinted the color of buckskin . . . The parlor is in mahogany and blue." Guests began to arrive at 8:30 p.m. and at 10:00 p.m. were served supper, catered by Herbert M. Kinsley's, considered the most fashionable restaurant in Chicago at the time. Dancing followed with music by Giuseppe Valisi's mandolin orchestra. One hundred guests attended the housewarming.

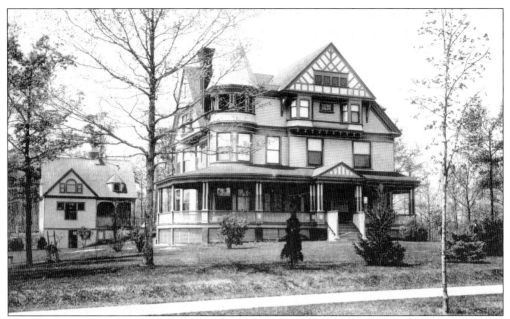

Palmer A. Montgomery, a successful Chicago insurance man, purchased 14 acres for $14,000 in 1890 and hired William W. Boyington to design his Queen Anne–style Sheridan Road residence and carriage house. The decorative half-timbering in the roof and porch gables was an unusual feature. Local resident Fred Clow, known as a master at his craft, had the construction contract. Samuel Parliament purchased the home around 1905.

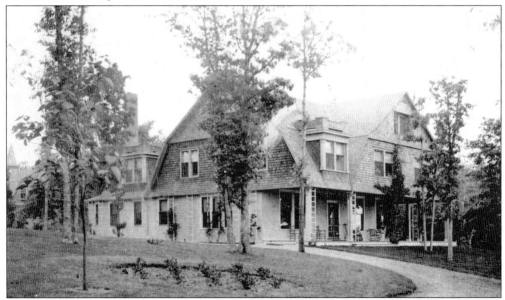

Yarrow, the residence of John McGregor Adams, was built in 1891 on Waverly Avenue. The property was believed to be a former camping ground of the Potawatomi, with remnants of a council ring still visible on the bluff overlooking Lake Michigan. Adams partnered with John Crerar in a railroad supply company. He became president of the firm, Adams and Westlake Company, in 1889 and was among Chicago's wealthiest men with a net worth estimated at $2 million in 1890.

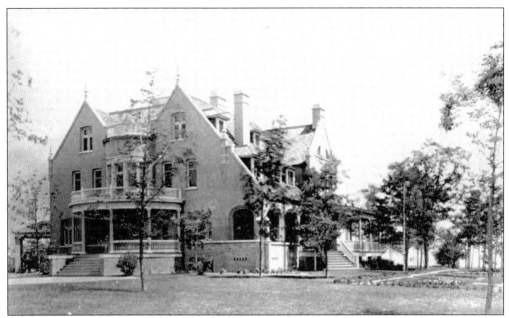

In 1892, Charles W. Fullerton purchased 20 acres overlooking Lake Michigan for $50,000. In 1895, he expanded the property by purchasing an additional five lots along Sheridan Road. He built a Tudor Revival house known as Ravinoaks. The carriage house featured a dovecote, reflecting the medieval period of the Tudor Revival style when doves were a prized possession. Ownership of a dovecote was a privilege reserved for the nobility. Fullerton Hall at the Art Institute of Chicago was a gift of Fullerton in memory of his father, Alexander N. Fullerton. Charles, who inherited large real estate holdings after his father's death and expanded them during his own lifetime, died without a will on December 6, 1900. His $2 million estate became the subject of family discord. Ravinoaks was purchased by Charles T. Boynton, vice president of Pickards, Brown and Company.

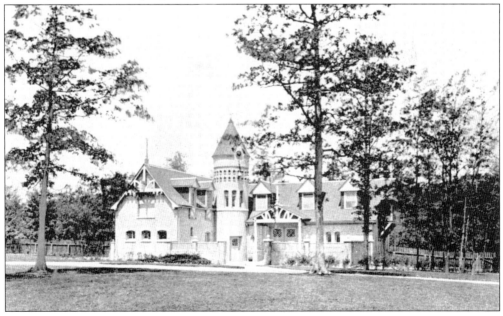

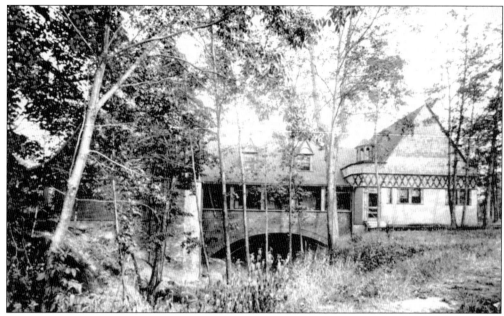

The Highland Park Club was formed on December 4, 1891, with James H. Shields as its president. Its membership represented a who's who of Highland Park society. The object of the club was to promote social, athletic, and aesthetic culture; to maintain a library and art collection; and to cultivate a taste for music. The clubhouse, designed by Irving K. and Allen B. Pond, was constructed in 1892 at Central and Lake Avenues.

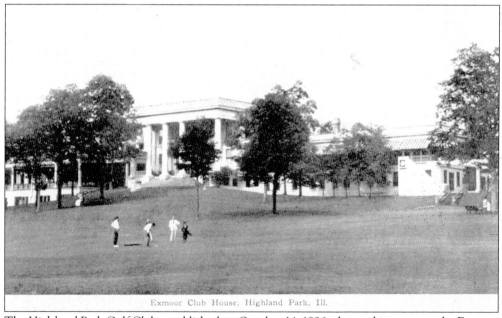

The Highland Park Golf Club, established on October 14, 1896, changed its name to the Exmoor Country Club on January 11, 1897. The new name was taken from the novel *Lorna Doone*, a best seller of the day. Vernon Cassard and Everett L. Millard conceived the idea for Exmoor and gained the financial support of William Arthur Alexander, who purchased the Stupey farm, constructed the classic-style clubhouse, and served as Exmoor's first president.

The Exmoor links extended west toward the Skokie River. With only one other golf club on the north shore, Exmoor was heavily patronized and required the expansion of its grounds and clubhouse in 1898. William Arthur Alexander and Charles W. Fullerton, the club's second president, funded those efforts. Exmoor received national recognition when one of its members, Henry Chandler Egan, son of William C. Egan, won the national amateur championship in 1904 and 1905.

Hugh Taylor Birch's Bobolink farm was converted into the Bob O'Link Golf Club in 1916. It became a men-only golf club in 1921, prompted when former members of Exmoor Country Club (which allowed women golfers) joined to avoid the slower play of women on the course. This 1896 photograph shows the original groundskeepers enjoying the greens.

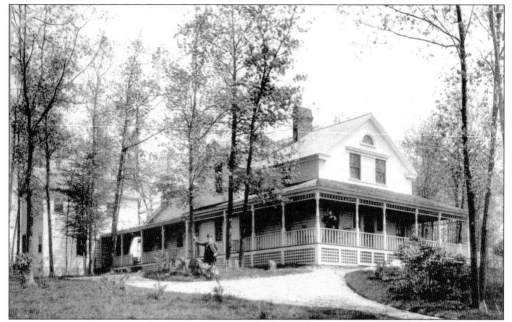

Hugh Taylor Birch is pictured at his Bobolink farm residence on Green Bay Road in 1896. He began purchasing Highland Park real estate in the 1880s and eventually accumulated hundreds of acres, including extensive holdings of lakefront property. Birch was a well-known Chicago lawyer and the first assistant state's attorney in Cook County, from 1872 to 1876.

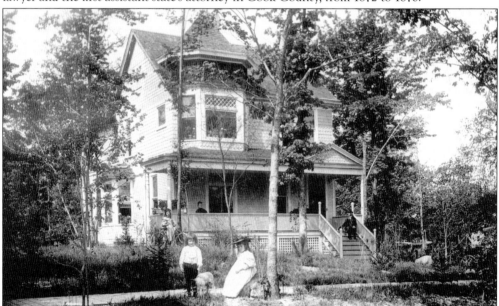

Henry K. Coale, pictured in 1896 on the steps of his Prospect Avenue home with wife Caroline and children (from left to right) Helen, Henry Jr., and Mildred, came to Highland Park in 1894, opened a real estate office, and selected the sites for Ravinia Park, the hospital, and the St. Johns Avenue location for city hall. An internationally respected ornithologist, Coale had one of the finest private collections of stuffed birds in the United States and helped establish the collections of the Field Museum and British Museum.

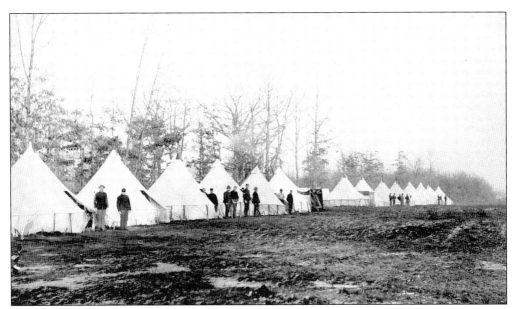

Following the Haymarket riot on May 4, 1886, Chicago businessmen desired a nearby military presence to protect property and maintain order during a time of labor unrest. A military post was established north of Highland Park, and Companies F and K of the 6th Infantry, commanded by Maj. William John Lyster, took possession of the property on November 8, 1887. Known as the Camp at Highwood at the time of this December 1887 photograph, the name was changed to Fort Sheridan on February 27, 1888, in honor of Lt. Gen. Philip Henry Sheridan. In September 1888, $300,000 was appropriated and the Chicago architectural firm of Holabird and Roche was hired to construct buildings at the fort. A water tower, flanked by barracks, was built in 1891 and stood over 227 feet tall but was reduced in height by 60 feet in 1949 when a structural weakness was discovered in the roof section.

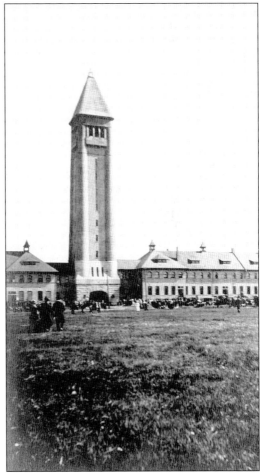

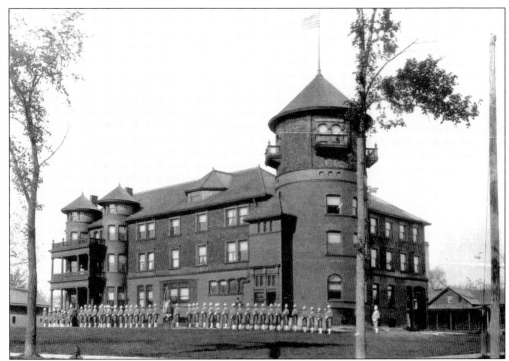

Col. Harlan Page Davidson purchased Highland Hall and opened the Northwestern Military Academy in May 1888. When Highland Hall was destroyed by fire the following November, it was replaced with this imposing brick building in 1889, designed by William W. Boyington to accommodate 75 cadets. It was part of a 15-acre campus at St. Johns Avenue and Ravine Drive. After it was destroyed by fire on May 1, 1915, the academy moved to Lake Geneva, Wisconsin.

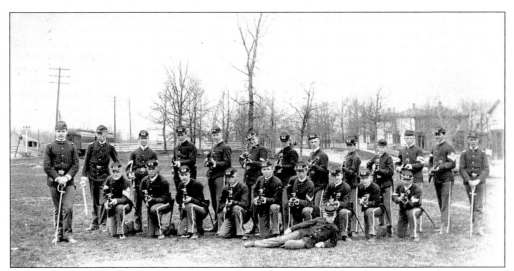

Northwestern Military Academy cadets took aim on a course of study to prepare for admission to college or commercial or military careers. Their 1905 yearbook notes, "The world has an abundance of ordinary men." The academy, on the other hand, promised to produce men of sturdy physique, sound scholarship, and high moral and spiritual ideals who would become leaders in the world of industry and commerce.

In 1887, the city council approved $1,000 to construct a frame city hall, but citizens disapproved of a cheap building. The council repealed its action, promising "a good building or none." In July 1889, a city building was constructed at the northeast corner of Green Bay Road and Central Avenue. Contracts were given to Alfred St. Peter for carpenter work and William Obee for excavating, masonry, and brickwork. The original building included a fire station. After a devastating 1892 fire destroyed an entire downtown block, a water standpipe and pumping station (at the lakefront) were constructed in 1893. The fire station was relocated and the city building altered. A November 1892 ordinance outlawed the construction of any but stone or brick buildings in the six-block business center.

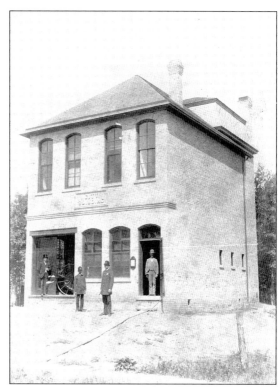

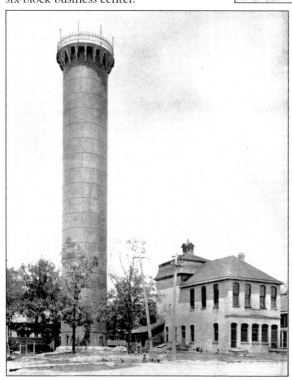

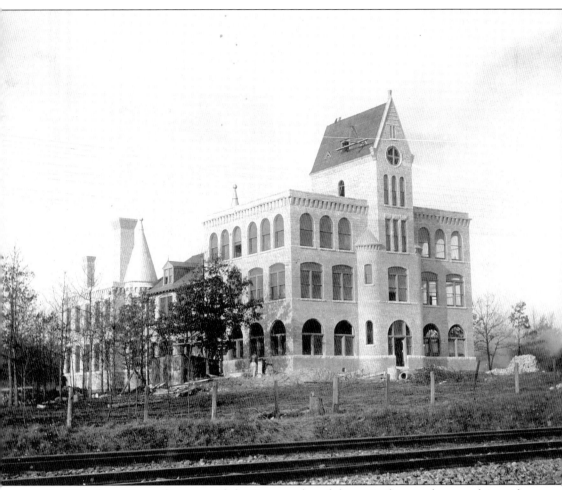

In 1883, electrician and inventor Elisha Gray purchased the entire frontage between his residence on Hazel Avenue and the railroad with the intention of locating an electrical laboratory on the property, but concerns from city leaders and neighbors caused him to relocate the building to St. Johns Avenue at Beech Street. There he purchased 50 acres for $25,000 as the site of a manufacturing plant and homes for the 200 men he expected to employ in the manufacture of the telautograph (an early version of the fax machine) and other electrical appliances and supplies. The Gray Electric Company building, designed by William W. Boyington, is under construction in this February 1892 photograph. Gray invented the telautograph in 1888. The machine created a sensation when it was exhibited at the 1893 World's Columbian Exposition.

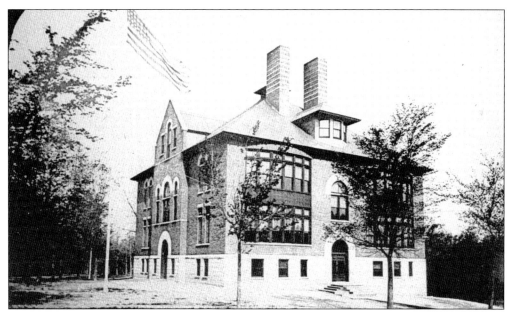

Elm Place School opened on October 20, 1893, replacing the old Port Clinton Avenue School. It was a two-story, eight-room building with wide halls and stairways and a large attic, which was used as an auditorium. In 1905, an addition with six classrooms was constructed and a telephone installed.

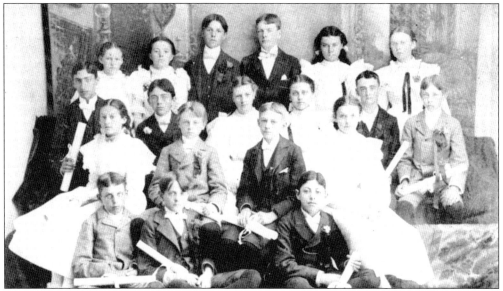

The 1897 eighth-grade graduates of Elm Place School (not all are identified in the photograph) are George Hawley Bowen, John Pearson Bubb, Helen Margaret Clark, Ellen May Clark, James Campbell Everett, Raymond W. Flinn (second from right in the second row), Anna M. Goldberg, Arthur F. Loeb, James Russell Loeb, Edward Moroney (second from right in the third row), Charles Winder Mason, Emma O. Nelson, Cecile Nevins, Helene Oglivie, Harry Carbine Sampson, Laura Schneider, Rosanna J. Steele, Ralph Gilman Thorn, and Jonathan Mayhew Wainwright (center in the first row). Wainwright succeeded Gen. Douglas MacArthur as commander of the Philippines during World War II.

Alta School, a private boarding school for girls, was founded in 1893 and closed in 1899. The school's brochure assured parents that the Linden Park Place location was healthful and attractive and that neither the school nor home building required students to ascend above the second floor to prevent "the frequent climbing of stairs, often so injurious to the health of school girls."

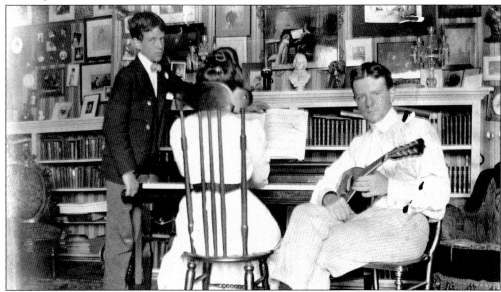

With her back to the camera in this 1899 photograph, professional musician and teacher Annetta R. Jones is accompanied by Russell Jones on the mandolin. (The boy at left is unidentified.) The mandolin gained popularity among young society women by the mid-1880s and was prominent in fashionable drawing rooms. Russell, left tackle for the Highland Park junior football team, may have taken up the mandolin while recuperating from a broken leg sustained in an October 1896 game.

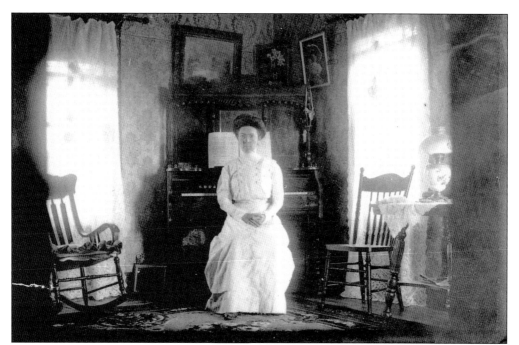

Music teacher Charlotte Brand awaits her next pupil in the parlor of her home on Second Street. Brand also performed as an accompanist for musicals at Goldberg's hall. Isaac Goldberg erected a building in 1895 on the north side of Central Avenue between First and Second Streets. The first floor was occupied by two businesses, the second floor by two flats, and the third floor by a hall and theater for dances and plays.

Orson Benjamin Brand constructed this building on Central Avenue in 1895. He maintained an active business as a professional photographer and produced an extensive catalog of work before his death on September 30, 1935. As amateur photography gained in popularity, he also specialized in developing, printing, and mounting that work.

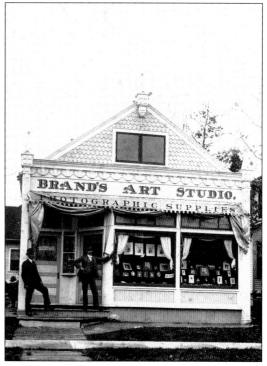

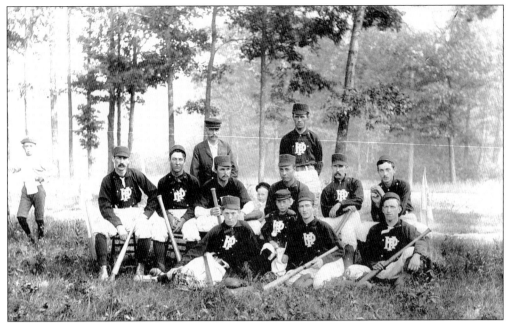

The Highland Park baseball club was photographed around 1894. From left to right are (first row) Ford Carter, Lyman Prior (boy), George McNab, and ? Olander; (second row) unidentified, Fred Glader, Win Ellis, Percy Prior (child), unidentified, Joe Ellis, and Frank Warren; (third row) Henry Prior and unidentified. The boy at the far left is unidentified.

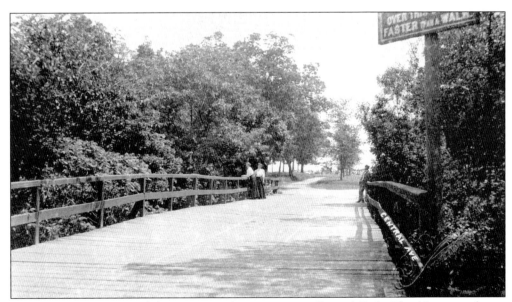

A wooden bridge spanned the ravine at the entrance to Central Park. The 10-acre park was created as part of the city's original landscape design. An 1870 ordinance made it a crime to ride or drive over any public bridge at faster than a walk. Violators were fined $5.

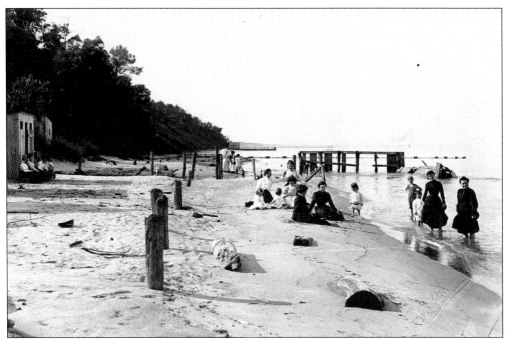

The sandy beach at Central Park was a favorite summer destination. Swimming was not a widespread skill when this photograph was taken in the early 1900s. Beachgoers simply bathed themselves in the cooling water. Beaches were referred to as bathing beaches and the special attire as bathing suits.

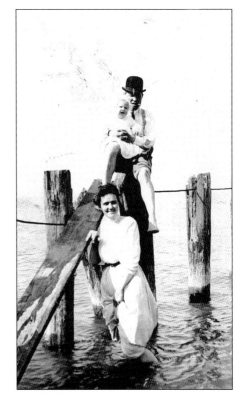

William Guyot, district superintendent for the Public Service Company, enjoys the Central Park beach with his wife and son, Clementine and William, in this 1908 photograph. In 1910, Guyot helped form the businessmen's association.

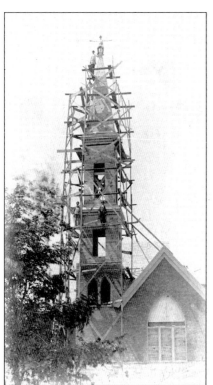

Builders of the United Evangelical Church at Green Bay Road and Laurel Avenue erected this inspiring steeple when the church was built in 1896. It proved unstable and was lowered years later.

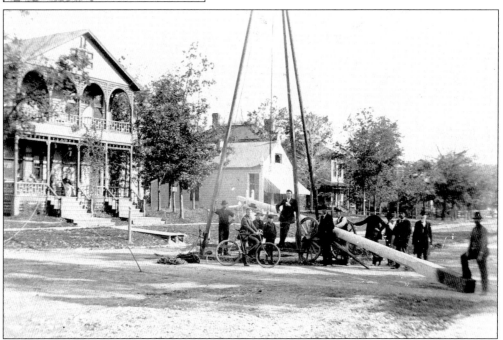

The first flagpole in Highland Park was donated by the Daughters of the American Revolution and was erected at the corner of Central Avenue and Sheridan Road. This photograph was taken at 9:30 a.m. on October 15, 1896. The 104-foot wooden staff displayed a 25-foot flag. It was replaced in 1925 by a metal pole.

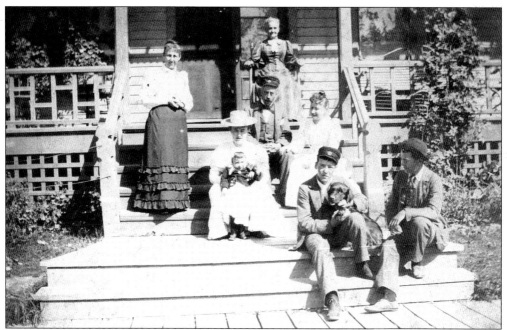

The building at left in the previous photograph was the bakery and residence of Frank B. Green. Seated here on the porch is Frank's mother, Elvira Green, who, with her husband, Harvey, operated the Highland Park Hotel in the 1880s. Standing at left is Emma McQuiston, Frank's sister. Her two sons, Harvey (left) and Paul, are in front. Mamie and Gladys Burns and Frank and his wife, Bertha Baker Green, complete the group.

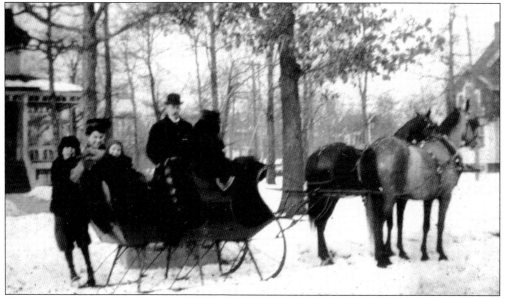

The Cobb family was photographed in 1907 with a sleigh at its Laurel Avenue home. Daniel M. Cobb was mayor from 1897 to 1901. His wife, Ida, was active in the Ossoli Club, a women's social club formed in 1894, and in the Highland Park Woman's Club. Their sons were Daniel L., standing behind the sleigh, and Robert (Melville), seated next to Ida. A daughter, Annie, is not in the photograph.

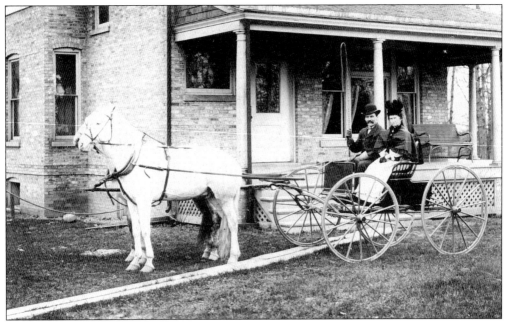

Charles Sheahen and wife Louise pose with a matched pair of horses in front of their Green Bay Road home. Charles's father, Patrick, came to Highland Park in 1859 and owned a farm that later became the site of Sunset Woods Park. Charles was noted for having a team of ponylike horses that usually got the job of pulling the hook and ladder wagon for the volunteer fire department.

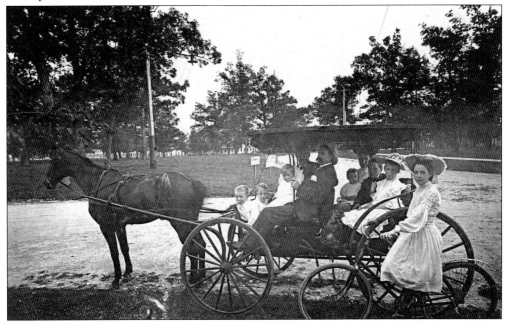

In 1896, Henry and Sara Ewart came to Highland Park where Henry opened a blacksmith shop. Their children are not identified in this c. 1904 photograph but included two sets of twins. From oldest to youngest, they were John, Isabelle, Ellen, and twins Gordon and Douglas and Lloyd and Lillian.

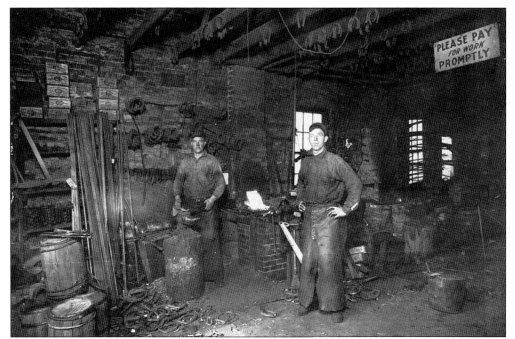

Nels Dahl (right), with Al Johnson in this 1919 photograph, bought Henry Ewart's blacksmith shop. Dahl converted from horse to automobile blacksmithing and in 1929 opened a "bump" shop in a new building on First Street. Bump shops handled auto body repair.

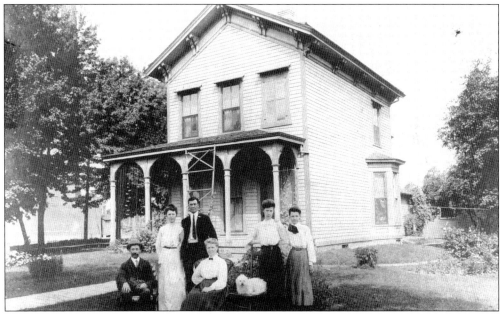

John and Johanna Freberg came to Highland Park in 1885, and John started a livery and boarding stable. His barn on St. Johns Avenue just north of Elm Place was headquarters for the Irish Company, one of two volunteer fire companies that operated in Highland Park. Pictured from left to right in front of their Elm Place home are John, Selma, Edward, Johanna, Alma, and Lillie.

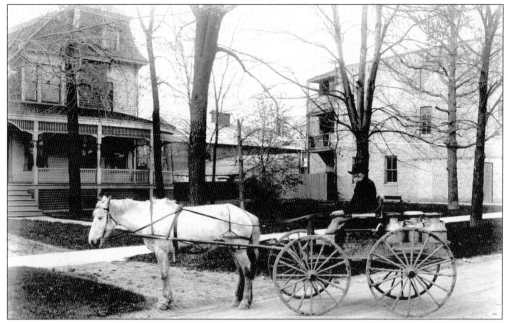

John Mooney came to Highland Park as a boy in 1844. The family established a farm and operated a dairy at the corner of Deerfield and Old Skokie Roads. Mooney is credited with being Highland Park's first milkman. He is seen in this photograph in front of the Central Avenue home of Archibald W. Fletcher.

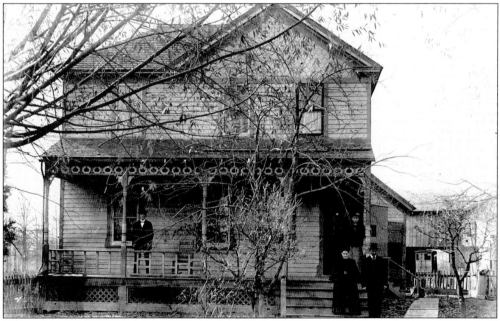

The Ohlwein family also operated a dairy. An 1898 advertisement promised "genuine Jersey milk and cream from Mr. [Hugh Taylor] Birch's farm." Henry Ohlwein and wife Martha came to Highland Park in 1885. Standing on the porch in this c. 1904 photograph are son Dithmar (Tip) and daughter Anna. The business ended in 1908 when Dithmar was struck and killed by a southbound Chicago and Milwaukee Electric Railway train while making deliveries.

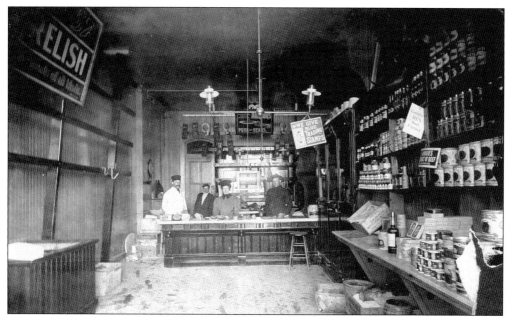

Harry Mills opened a meat market on St. Johns Avenue in 1889 and operated it until his death in 1904. Individuals in this photograph are not identified, but Mills is believed to be the man at the far left and his wife, Sara Jane Sheahen, the third from the left. For an exterior view of Mills Meat Market, see page 102.

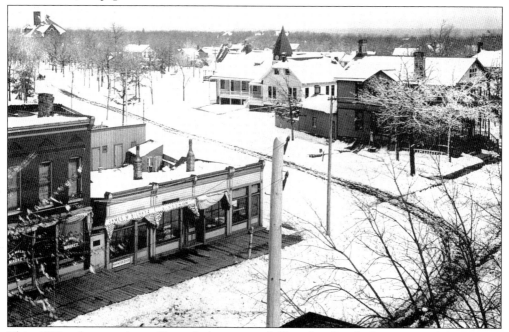

This 1890s photograph at Central Avenue and Sheridan Road shows several businesses. Albro W. Waldo Jr. opened his meat market in 1892. James M. Bilharz's harness shop opened in 1894. Enoch Nelson started a tailor shop in 1895. David M. Erskine Jr.'s real estate and insurance office was at the corner. On September 5, 1899, Erskine opened Highland Park's first bank at this location with Mabel Noerenberg as cashier.

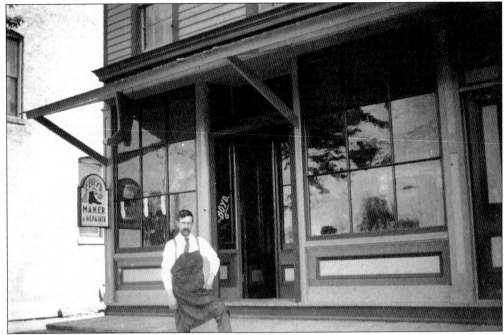

This photograph from around the 1890s shows the E. Boyd shoe repair shop at the St. Johns Avenue location that was later occupied by the Highland Park News.

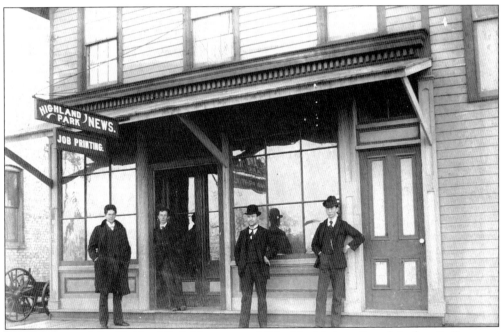

The first issue of the *Highland Park News* was published by Herbert F. and Arthur E. Evans on December 4, 1896. Pictured from left to right at the office north of McDonald's store on St. Johns Avenue are Herbert F. Evans, John Fay, Arthur E. Evans, and Tom Forrest. In June 1897, the office moved to Central Avenue.

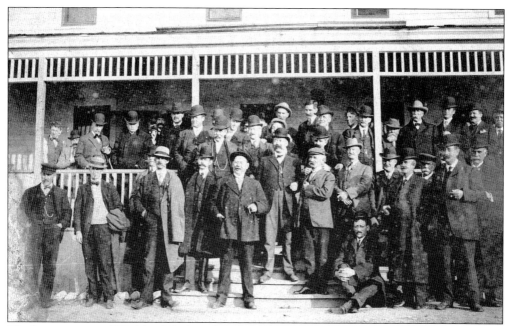

The businessmen of Highland Park gathered for this 1890s photograph. They are unidentified except for George B. Cummings, seated on the step. The Highland Park Business Men's Association was formed on September 19, 1910, with Charles M. Schneider as president and Albert Larson as the secretary. The association became the Highland Park Chamber of Commerce on August 10, 1925.

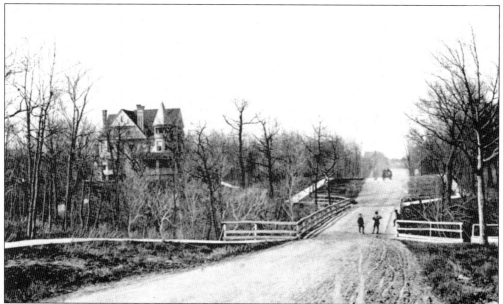

In 1889, a magnificent drive, known as the Sheridan Road, was planned to extend from Chicago north along the lakeshore to Waukegan. In places it was an entirely new road cut through forests and spanning ravines; in other places existing roads were used. This 1889 photograph shows Port Clinton Avenue between Maple Avenue and Moraine Drive shortly before it became part of Sheridan Road. Palmer A. Montgomery's house is on the left.

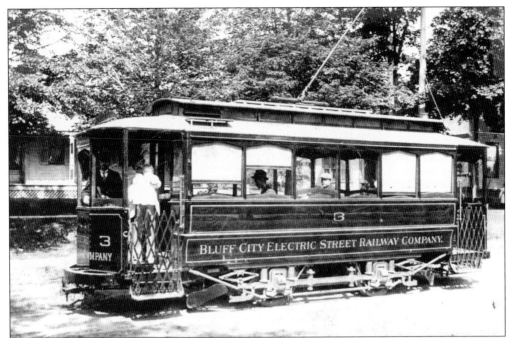

On April 15, 1895, the Bluff City Electric Railway received a franchise to run an interurban railroad along the north shore. By May 1896, cars were operating between Waukegan and North Chicago. In 1898, Albert C. Frost and George A. Ball (manufacturer of Ball canning jars) acquired the property, and the Chicago and Milwaukee Electric Railway Company was incorporated. The line ran from North Chicago south to Highland Park and in 1899 was extended from Highland Park to Evanston. It ran along St. Johns Avenue as seen in the view of Laurel Avenue looking east from the viaduct (below). The company was renamed the Chicago North Shore and Milwaukee Railroad in 1916 after it was purchased by Samuel Insull. A speedy interurban railroad greatly enhanced Highland Park's potential as a residential community for commuters working in Chicago.

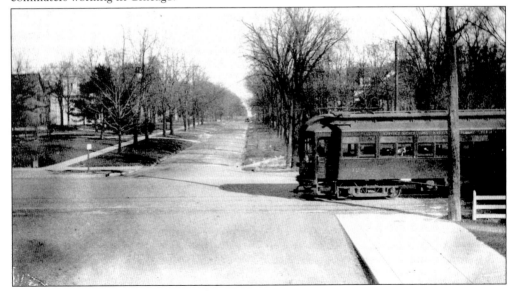

Three
PROGRESS IN A NEW CENTURY

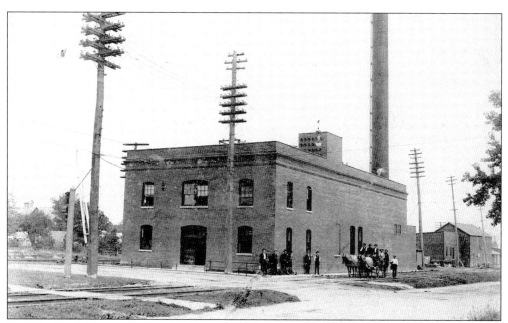

Highland Park Electric Light Company was founded in 1890 by Bernard E. Sunny, Frederick W. Cushing, and George A. and William H. McKinlock. John D. Mersereau bought the plant from the founders in 1896 and served as president, with Arthur G. McPherson as the manager, until the company was sold to Samuel Insull of the North Shore Electric Company in August 1902. The power plant building, located on the northwest corner of Elm Place and St. Johns Avenue, was remodeled into this brick structure in 1902. North Shore Electric was one of the original constituent companies of the Public Service Company of Northern Illinois when it organized in 1911. The Public Service Company became a division of Commonwealth Edison in 1953.

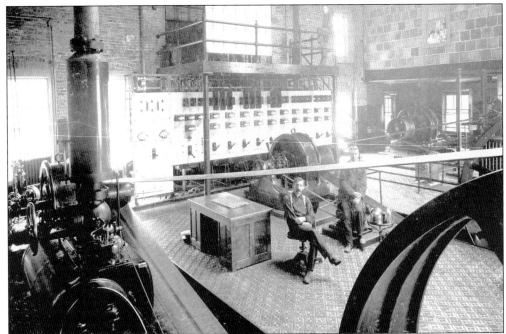

An interior view of the power plant shows the large steam-powered engines belted to the generators. In the 1890s, the plant provided electric lighting from 4:15 p.m. until 1:00 a.m. to homes in Highland Park and Highwood. Wires were extended to Lake Forest to light the homes of Frank Farwell, John V. Farwell Jr., and Cyrus H. McCormick.

Gervase L. Brown read meters for the Public Service Company. He was photographed on St. Johns Avenue in April 1915 with his horse Jerry.

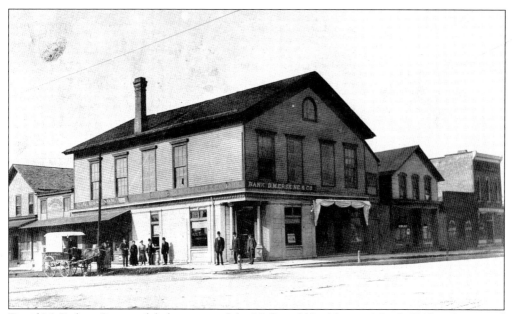

David M. Erskine Jr. remodeled a corner of the McDonald building in March 1900 and operated his real estate, insurance, and banking businesses from that location until his death in 1916. Charles G. Rosenow operated a grocery store in the building. Erskine demolished the McDonald building and, in 1908, constructed a three-story classical-style structure. The bank was the scene of a desperate robbery on October 13, 1909. Cashier John C. Duffy was robbed of around $500. The escaping robber shot marshal John (Jack) Sheahen, wounding him in the left arm. Pursued by the wounded marshal and a number of nearby businessmen, the robber fled into neighboring buildings and attempted an escape across the railroad tracks where he was trapped against the fence that separated the electric line tracks from those of the Chicago and Northwestern Railroad. Facing certain capture, he took his own life.

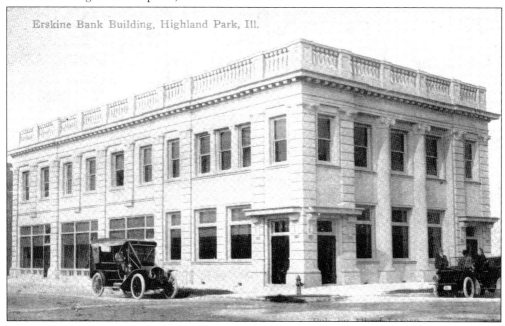

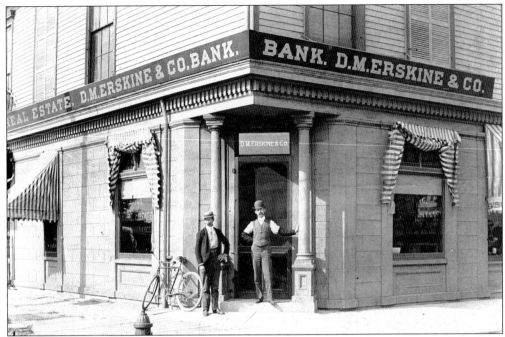

Alonzo Jones (left) and John C. Duffy, cashier, are pictured in the doorway of the Erskine bank. Duffy is wearing black sleeve protectors to prevent ink from staining his shirt. He started with Erskine on April 28, 1900, after 12 years with the Northwestern Railway. An article in the local newspaper congratulated David M. Erskine Jr. on his "sagacity and business wisdom" in hiring Duffy.

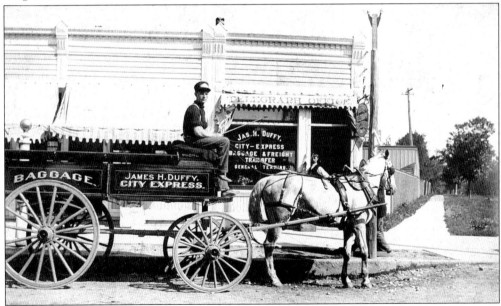

John C. Duffy's brother James Henry Duffy moved into Erskine's former business location at the corner of Central Avenue and Sheridan Road and operated an express baggage delivery service and telegraph office. James started his career as a messenger boy for the Northwestern Railway. He learned telegraphy and was promoted to agent. After 15 years with the Northwestern Railway, he started his own express business.

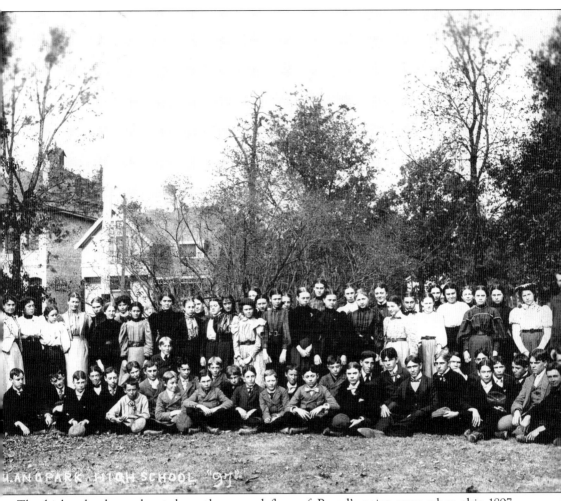

The high school was located on the second floor of Brand's paint store when this 1897 class photograph was taken. From left to right are (sitting) James Troxel, Edward Moroney, unidentified, Charles Finney, John Osborn, William Landt, Harry Evans, Sam Hole, Eber Woodruff (kneeling), Harry Sampson, James Shields, unidentified, Raymond W. Flinn, Charles Mason, Thomas Troxel, Edward McTamaney, William Fitzgerald, Arthur Loeb, John Grant, ? Ott, unidentified, George Millard, Frank McCaffrey, Ira Hole, Tom Gail, James Loeb, Frank Conrad, John Obee, John Bubb, Warren Boyington, and two unidentified; (standing) Ann Douglas (teacher), Ethel Aldrich, unidentified, Maude Stewart (teacher), Clara Keys, Charlotte Brand, Ellen Cox, Helen Clark, Bessie Cheverton, Nellie Palmer, unidentified, Mildred Mihills, Isabel Clark, Mamie Cox, Emma Turtle, Mary Lamb, Celia Nevins, Frances Bryant, Emma Nelson, Gertrude Brand, Anna Goldberg, Hattie Noerenberg, Lulu Dautle, Maude Inman, Jennie Grant, Emma Solig, Nellie Clark, Jennie Vetter, Rose Steele, Belle Biederstadt, Mamie Kenney, unidentified, Bertha Bell, and principal W. A. Wilson. The city building is at the left rear.

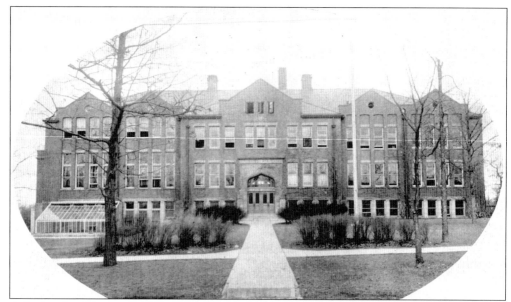

A high school building (Shields Hall), designed by Joseph C. Llewellyn, was completed in September 1900. Located at the corner of St. Johns and Vine Avenues, it was designed to house 400 students and had an enrollment of 99 its first year. Students from Lake Forest began attending in 1904. It was known as the Deerfield-Shields High School from 1912 until 1936 when Lake Forest built a high school. Shields Hall was demolished in 1953.

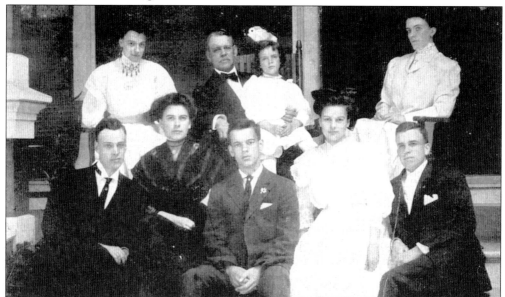

James H. Shields served on the high school board from 1895 to 1912. He helped secure the new high school building, which was named in his honor. The nephew of Leander and Cyrus McCormick, Shields came to Highland Park in 1886 and also served as an alderman from 1889 to 1899. Pictured at their Prospect Avenue home, Villa Vue d'Eau, in 1907 are Shields (second row, second from left), wife Nellie (first row, second from left), and their children, Elizabeth (on Shields's lap), Constance (first row, second from right), and, unidentified in the photograph, Viola, Caroline, Charles, Robert, and James.

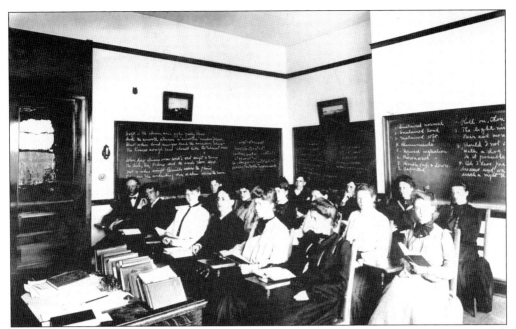

Augusta Stuart's Latin class was photographed for the yearbook in 1904 or 1905. Pictured from left to right are (first row) Henry Bell, Frank Golden, Elizabeth Kemp, William B. Rice, unidentified, and Donna Drew; (second row) Herbert Moon, Elsie Brand Grant, Annie Helen Enmark, unidentified, Katherine Pease, and Estelle Clark; (third row) four unidentified students.

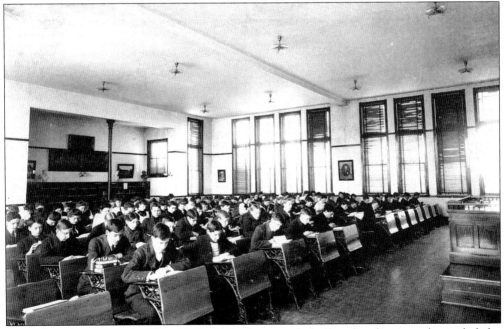

Located at the west end of Shields Hall, the large study hall and auditorium also included a library of nearly 500 books. A raised desk at the front of the room allowed the teacher to be seen by (and to see) all students even while sitting.

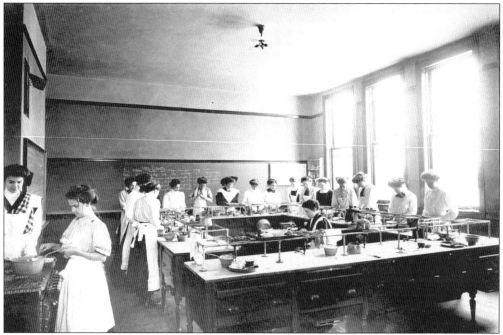

Beginning in September 1904, high school girls received training in domestic science, which taught house management, hand sewing, cookery, dietetics, and home nursing. The blackboard shows a recipe for potato croquettes.

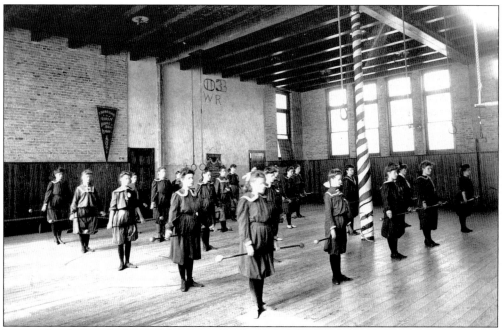

Boys and girls shared a basement gymnasium for physical culture classes. This 1903 photograph shows a pennant in the background won by the girls' basketball team.

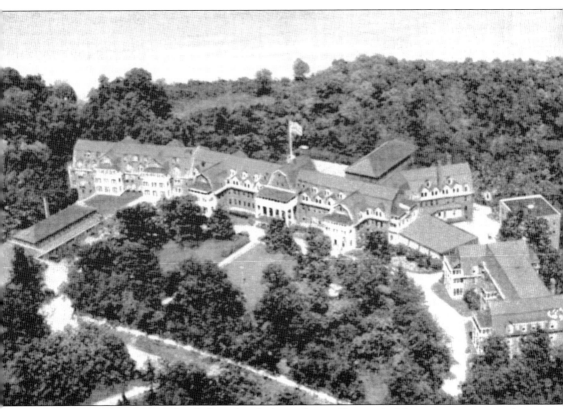

Hotel Moraine, designed in the Colonial style by architect Ernest A. Mayo, was constructed by Frederick W. Cushing. Cushing expended a half million dollars to create a luxurious resort hotel that could accommodate 1,000 guests. It was located on 13 acres at Sheridan Road and Moraine Drive and opened on June 1, 1900, with every room reserved. The Moraine offered a private beach, clambakes, horseback riding, lectures, recitals, regattas, Ping-Pong and tennis tournaments, card parties, coaching parties, and a number of other diversions for its fashionable clientele. A 1902 newspaper article proclaimed, "The Moraine has solved the oft propounded problem, by providing a hotel at once remote from all the hurly burly of big commercial centers and yet so accessible to the same as to make it possible for men of affairs with large business interests which cannot always be neglected for a prolonged period, to attend daily to their affairs and still enjoy a pleasant, healthful summer outing with their families away from the city's heat and turmoil." The hotel was demolished in 1971.

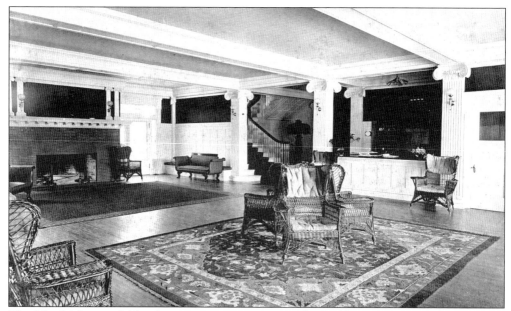

The Hotel Moraine lobby shows a spacious interior. The building also provided a ballroom where dances were held on Tuesday and Saturday evenings, private dining rooms, a children's playroom, a smoking room for male guests, and many other luxury appointments. Guest rooms were described as "uncommonly large" and were nearly all arranged en suite, with a private bathroom and a long-distance telephone.

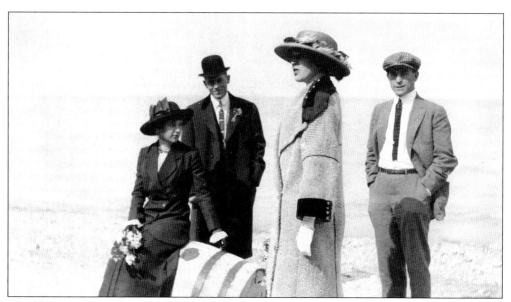

Hotel Moraine guests could stroll along the beach or enjoy bathing, boating, and other water activities. Walking trails along the bluff and over rustic bridges at the ravines offered the opportunity to gather wildflowers. The barrel was used for clambakes.

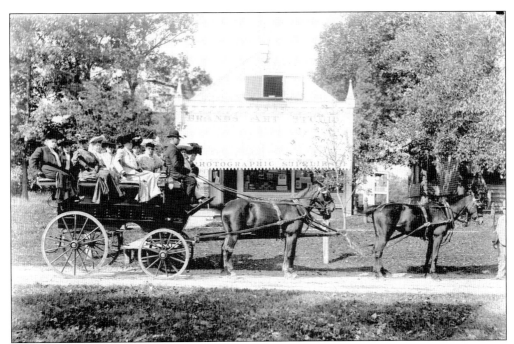

Martin Ringdahl's livery, working for Hotel Moraine, carried guests between the railroad station and hotel. Ringdahl came to Highland Park in 1900. His livery also transferred passengers to the Exmoor Country Club. It required a skillful driver to handle the reins of this four-in-hand, or tallyho, carriage.

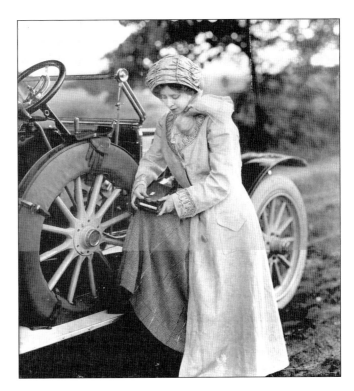

Horse-drawn carriages were replaced by the popular open touring car in the early decades of the 20th century. Attired in a driving coat and hat, Carol S. Lawrentz loads film into her camera at Hotel Moraine.

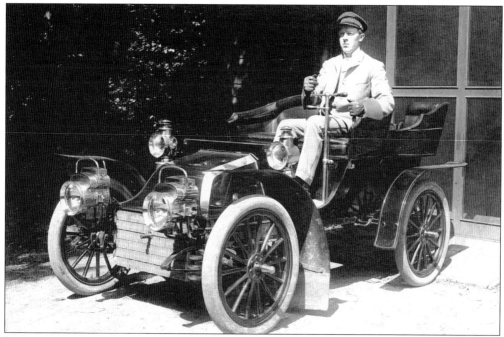

In a 1942 interview, Fritz Bahr, a longtime resident of Highland Park, said that Lewis O. Van Riper owned the first car in Highland Park. According to Bahr, it was such a novelty that it was displayed in a store window for a time. The unidentified chauffeur of this early car steers with a tiller. Steering wheels replaced tillers around 1900.

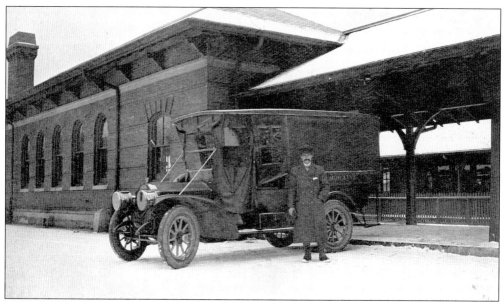

William McIlwain was a private chauffeur for Samuel Parliament until 1911 when he became a driver for Hotel Moraine. He is photographed at the train station with the Moraine bus.

The original Trinity Church was a frame building constructed in 1877. It was destroyed by fire in December 1899 and replaced by this English Gothic structure designed by architect Ernest A. Mayo. The cost of the building and furnishings was $15,905.22. It was completed in time for Easter Sunday services on April 7, 1901.

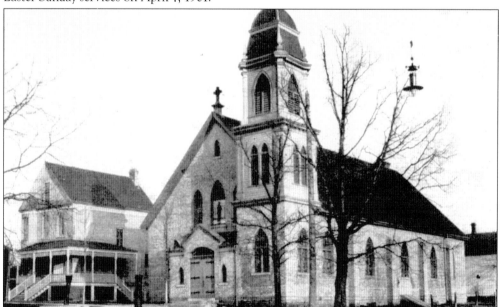

In 1871, the Highland Park Building Company donated land at the corner of Laurel Avenue and McGovern Street to the Catholic Church. A frame building, St. Mary's Church, was constructed in 1872. It was destroyed by a tornado in April 1890 and replaced with a brick structure that was destroyed by fire in May 1903. Parishioners constructed the church pictured here in 1903 on the foundation of the burned structure. The name of the parish was changed to Immaculate Conception in 1912.

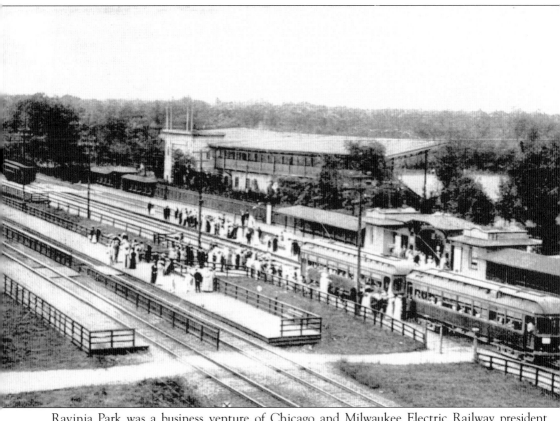

Ravinia Park was a business venture of Chicago and Milwaukee Electric Railway president Albert C. Frost to increase ridership by offering attractions along the line. When it opened in August 1904, the 40-acre park included a stadium for baseball and football games. During the winter, the playing field was transformed into a hockey and ice-skating rink. Park buildings were designed by architect Peter J. Weber and included a 24-room hotel (located west of the railroad tracks), a theater building, a casino containing a restaurant and ballroom, a pavilion, and the stadium. The theater offered "refined and high-class vaudeville" every day except Sunday. In 1907, the park was forced into receivership. Fearing that it would be purchased by a cheap amusement company, a group of prominent Chicago and North Shore residents organized to raise the $15,000 needed to save it. In 1911, Ravinia Park once again faced financial difficulty. Residents of the North Shore, led by Frank R. McMullin of Highland Park, raised $75,000 to purchase the park. On June 21, 1911, the Ravinia Company was incorporated.

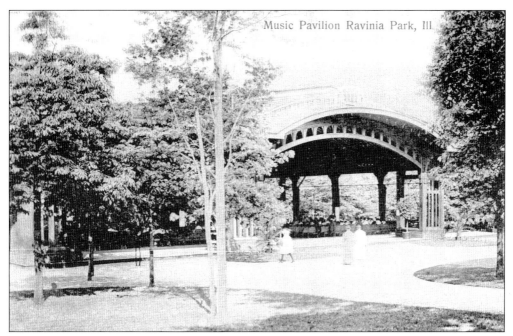

A pavilion was constructed at Ravinia Park in 1905. It provided seating for 1,420 persons under an arched roof. Its elevated stage was backed by a concave wooden sounding board with excellent acoustical properties. Summer concerts were given twice daily by the New York Symphony, under Walter Damrosch, and later the Minneapolis Symphony under the direction of Emil Oberhoffer. After the park became the property of the Ravinia Company, Louis Eckstein was appointed director. Under his direction, opera was added to the repertoire in 1913. The pavilion was destroyed by fire on May 14, 1949.

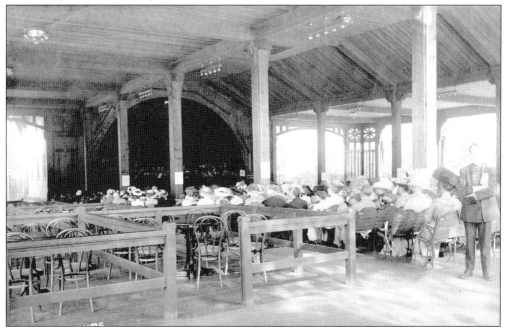

A Ravinia Park theater production around 1911 featured talented local players. From left to right are Marjorie Follansbee, William Cregier, "Queenie" Spencer, Jay Bournique, Marie Armstrong, George Moseley, Alice Leper, Edward M. Knox, Helen Hayne, Clarence Parliament, unidentified, and James Campbell McMullen.

A telephone exchange opened in Highland Park in December 1895 with 30 subscribers. By 1900, there were 188 telephones in Highland Park operated through a switchboard. Before telephone directories for Highland Park began publication around 1908, listings of local telephone numbers were printed in the newspaper.

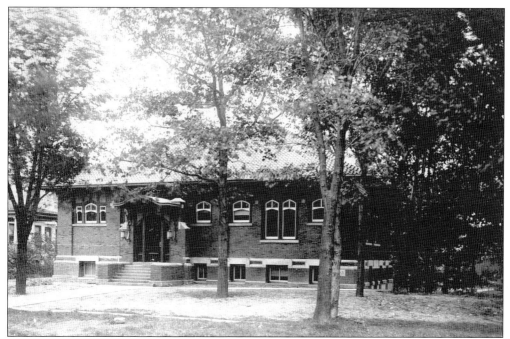

Since its establishment in 1887, the Highland Park Public Library has occupied many temporary locations. In 1905, the first permanent library building was constructed on Laurel Avenue with the assistance of philanthropist Andrew Carnegie, who donated $12,000 toward its construction. Designed by the Chicago architectural firm of Patton and Miller, the building was completed at a final cost of $17,893.27. It was demolished in 1929 when a new building in the modified Gothic style, designed by local architect Raymond W. Flinn, was constructed on the same site.

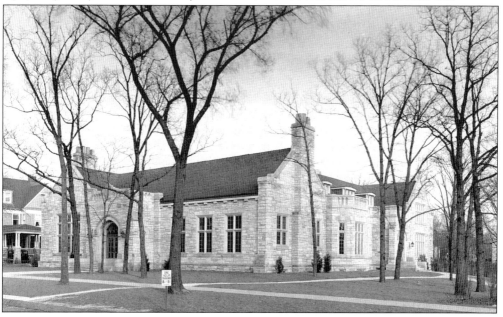

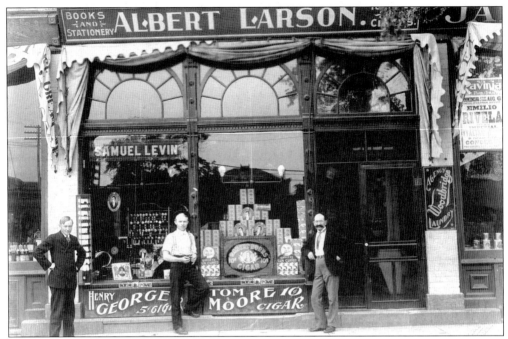

Albert Larson bought out the A. P. Dunn store in 1906 and remained briefly at Dunn's location in the corner of the Streeter building at St. Johns and Central Avenues. A short time later he moved to the St. Johns Avenue store pictured here. Jeweler Samuel Levin shared this location until 1908 when he moved his business to Central Avenue. Pictured from left to right are Samuel Levin, Edward Larson, and Albert Larson.

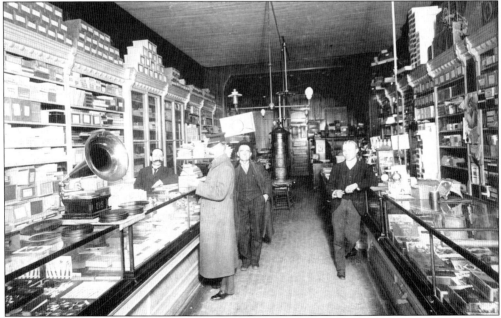

At the time of this photograph, the St. Johns Avenue store that housed Albert Larson's business was owned by E. F. Pratt, who sold cigars and musical instruments. Albert Larson is at left. The other three men are unidentified.

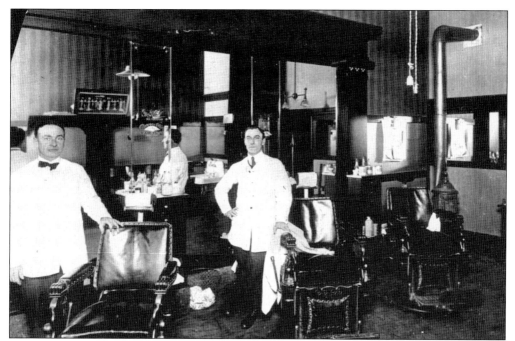

Photographed in 1908, Barney Stevens (left) and Fred Glader were barbers at Alfred Esmiz's shop on Central Avenue. Haircuts were 25¢ and shaves 15¢. Before King Camp Gillette invented the disposable safety razor in 1901, and for many years after, most men preferred the services of a professional barber to their own unsteady hands and the sharp edge of a straight razor.

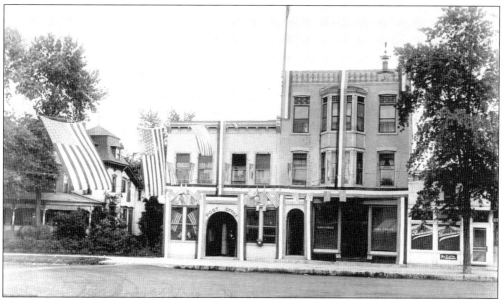

Archibald W. Fletcher owned these two business buildings at Central Avenue and Sheridan Road. The post office building was constructed in 1908. Charles Rosenow's grocery occupied the first floor of the adjacent building. Rosenow had been in the McDonald building but relocated when David M. Erskine Jr. demolished that building in 1907. Fletcher's residence is at left behind the flag. The street was festooned with flags for the annual Highland Park Day celebration.

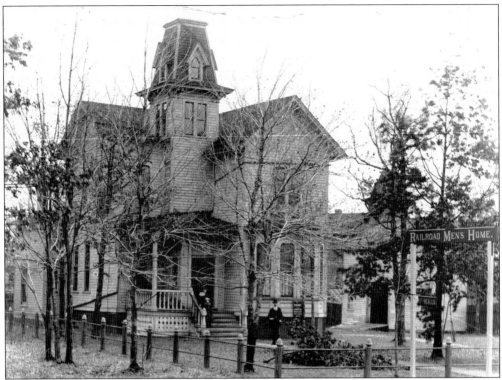

Built in 1871, the house above, near Beech Street, was one of four residences used as the Home for Aged and Disabled Railroad Employees beginning in 1893. The home was founded by Dr. Frank M. Ingalls, formerly a member of the Brotherhood of Railroad Trainmen, and was supported with voluntary donations from fraternal organizations of railroad men. In 1910, 31 men were living in the crowded houses with others waiting for admission. Through the efforts of the home's superintendent, John O'Keefe, $100,000 was raised for a new building. It opened on April 12, 1910, with rooms for 108 men. The home was a place of retirement for the aged and a place of rehabilitation for the younger men who were trained for occupations that accommodated their disabilities.

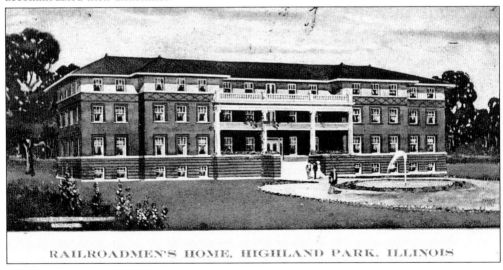

RAILROADMEN'S HOME, HIGHLAND PARK, ILLINOIS

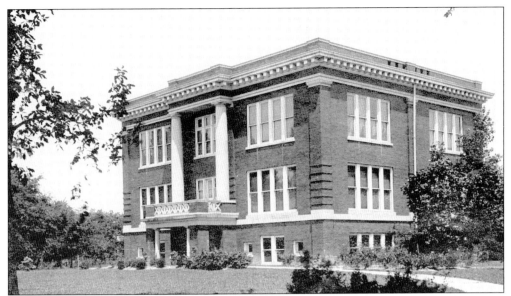

Built to replace Fairview School, Lincoln School opened in 1909, the centennial year of Abraham Lincoln's birth. In 1924, an auditorium/gymnasium and five classrooms were added. In 1928, the building was expanded again with a two-story section. At the urging of residents, the park district board created a four-acre park next to the school in 1928 to provide a playground for the children.

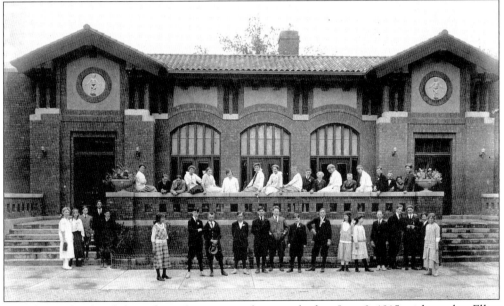

Elm Place School eighth-grade graduates were photographed on June 3, 1915, with teacher Ellen Guiney (eighth from the right on the terrace), at the primary building. Constructed in 1914, the building was designed by architect (and former student) Raymond W. Flinn and Morris Grant Holmes. Featuring the most modern design and furnishings available at the time, it was considered the ideal school building. Each classroom had an outdoor entrance—the kindergarten room through French doors onto a wide terrace. Skylights on the third floor lit an art gallery. Two copies of the Luca della Robbia bambinos decorated the entrance facade.

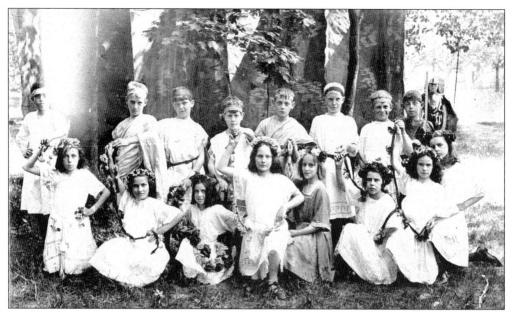

In 1911, those same students were in Winifred Canavan's fourth-grade class when they performed scenes from *Odysseus* at the June 2 school picnic. From left to right are (first row) Winnie Rogan, Dorothy Sheahen, ? Rafferty, Rose Nicholls, Beatrice Thayer, Florence Johnson, Henrietta Shreve, and Elizabeth Shields; (second row) Lyman Gurney, Henry Bell, Harry Stupple, Norman Schumacher, Harold Bamborough, Arthur Olson, Clarence Larson, and William Parker.

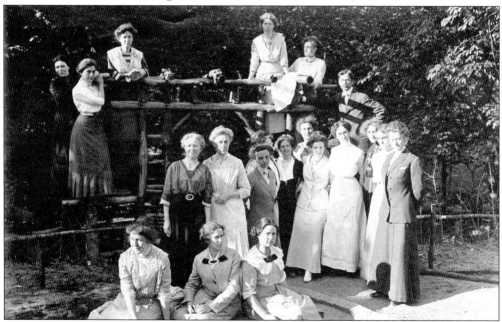

A rustic bridge, constructed on the Elm Place School grounds, is the backdrop for this faculty photograph taken on June 17, 1912. Teachers are not identified, but a few are recognized. Winifred Canavan is seated on the left. Standing in front of the bridge at left is Ellen Guiney, and next to her is Esther White. Etta Grunewald is in the pale dress, standing fourth from right, in front of principal Jesse Lowe Smith.

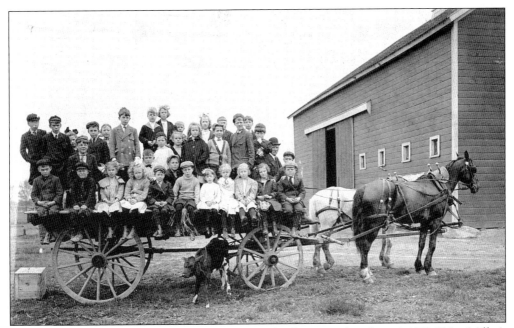

Elm Place School principal Jesse Lowe Smith noted in his journal on June 4, 1913, "Miss Miller's 3A's went to Arcady farm. I went, too." William Koller, the driver, is pictured on the wagon with the students. Rose Miller taught at the school from 1906 to 1913. Arcady Dairy was at Rondout, west of Lake Bluff.

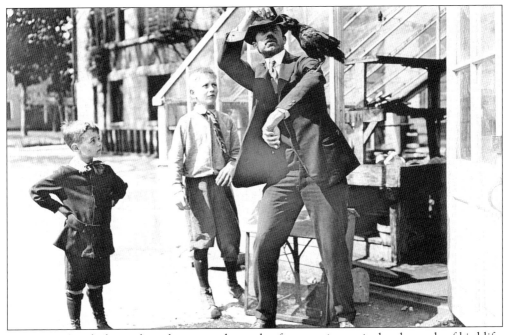

Jesse Lowe Smith devoted much time to the study of nature, in particular the study of bird life. He never lost an opportunity, in or out of the classroom, to share his enthusiasm for the subject with students. On June 5, 1920, he demonstrates the feeding of a pet crow to James Grant (left) and an unidentified boy. They are pictured outside the plant house at Elm Place School.

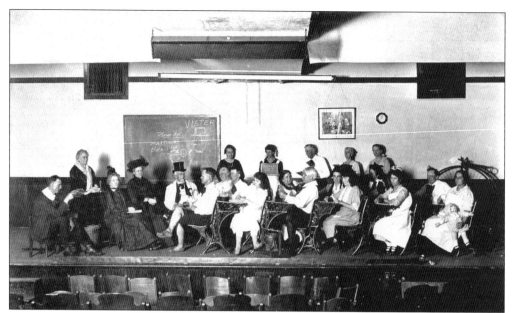

To raise funds for an auditorium at Elm Place School, community members staged the humorous production *School Daze* on May 3, 1923. The cast members are, from left to right, (sitting) Arthur Purdy, Ida Cobb, Della Everett, Paul Dyke, Sidney Dealey Morris, Mary Steers Brand, James Henry Duffy, Alice Green Winston, Evva Egan Truax, Orson Benjamin Brand, Mabel Noerenberg, Alice McCaffrey Duffy, Helen Clark Patton, Clara Bock Walther, Albert Larson, and Frances Kirby Larson; (standing) Bertha Baker Green (former teacher), Nellie Palmer Flinn, Charlotte Brand, Edward M. Laing, Hattie Davis Laing, and Annie Winchester Putnam.

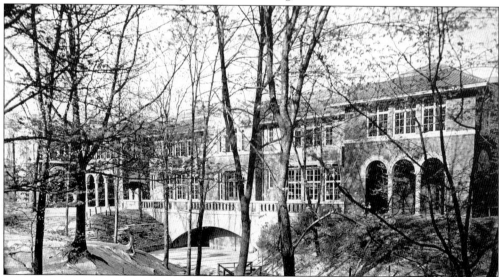

The Elm Place School intermediate building, designed by Herbert Beers, opened in 1923 for sixth through eighth grade. The building spanned a ravine. After a successful fund-raising campaign led by Robert E. Wood (later president of Sears, Roebuck and Company), an auditorium was added in 1924 and dedicated to Jesse Lowe Smith in 1932. Wood noted, "Elm Place School is a fine institution, in charge of . . . a superintendent whose single hearted devotion to the welfare of our children amazes everyone who knows anything about it."

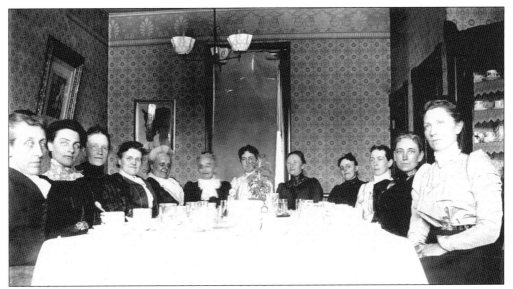

On September 5, 1899, a meeting was called at the residence of Laura Dayton Fessenden to consider formation of the Highland Park Woman's Club. Membership was open to women of intelligence and good character. They are, clockwise from bottom left, Emma McQuiston, Aggie Leslie, Adeline E. P. Cummings, Frances Haines Matteson, Laura Dayton Fessenden, Elvira Green, Maude Strickland Erskine, Bertha Baker Green, Zelina Look Brown, unidentified, Della Morrison, and Nathalia Van Riper. Fessenden was the club's first president.

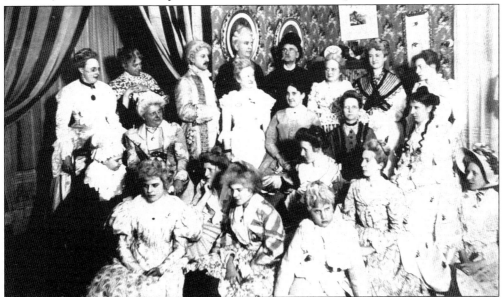

The club history noted, "On February 22, 1900, the club held a George Washington reception . . . Most of the ladies and their husbands appeared in Colonial costumes." From left to right are (seated on the floor) unidentified, Rena Brown, unidentified, Nellie Ogilvy, two unidentified people, and Hattie Davis Laing; (seated on chairs) an unidentified child, Laura Dayton Fessenden, Edith A. Holmes, Julia R. Purdy, and Nathalia Van Riper; (standing) Zelina Look Brown, Annie R. Warren, Lewis O. Van Riper, Bertha Baker Green, Edward Brown, De Witt C. Purdy, unidentified, Maude Strickland Erskine, and unidentified.

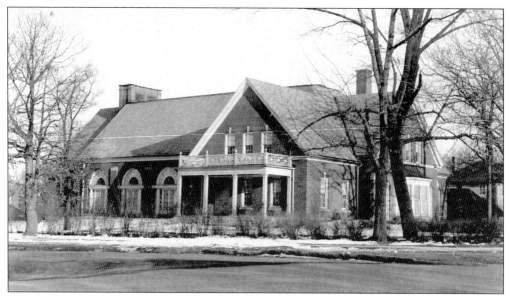

The Highland Park Woman's Club house, designed by architect Arthur G. Brown, was opened formally on February 27, 1924. As expressed at the time, "The plan of the club is to make their building a great community asset to be available for community uses of various kinds, and it is expected that revenues from its uses by outside organizations will practically cover the cost of maintenance."

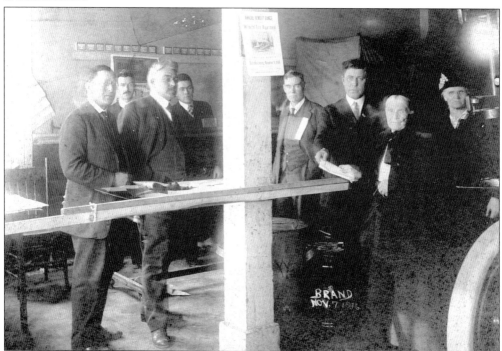

Ninety-one-year-old Salome Brand cast her first vote on November 7, 1916. Women in Illinois had won limited suffrage in 1913, and 1916 was the first presidential election with Illinois women voters. The Nineteenth Amendment to the U.S. Constitution, granting women the right to vote, was ratified on August 26, 1920.

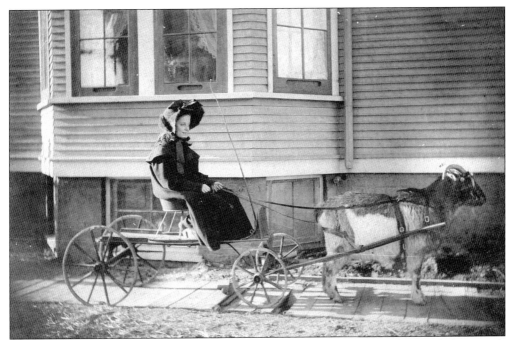

Nine-year-old Ethel Zimmer holds the reins of her trained billy goat in this 1905 photograph taken at her home on McGovern Avenue. During the winter, it pulled a sleigh.

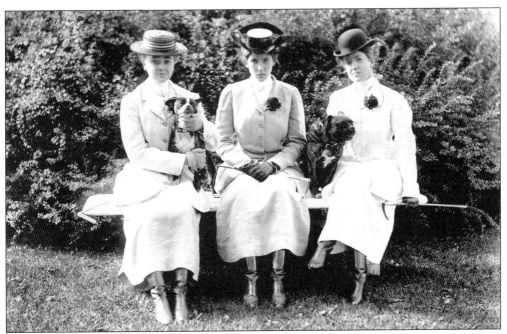

North Shore society women participated in horseback riding, coaching parties, and other equestrian events. Bridle paths connected private estates. For many years, the Lake Forest Horse Show Association hosted an annual show on the grounds of the Onwentsia Club. It was considered one of the premier events on the North Shore social calendar.

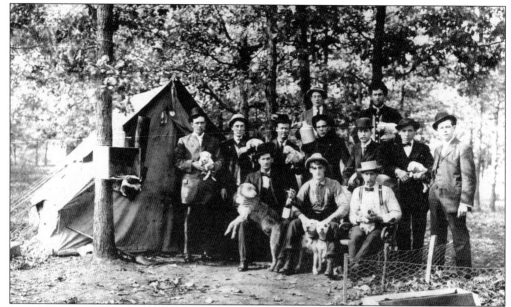

Young men from Highland Park set up bachelor quarters in Patrick Sheahen's woods (later Sunset Woods Park) in this September 1907 photograph. From left to right are (first row) Lindy Russell, Edward Moroney, and Mike Duggan; (second row) George Duffy, John O'Donnell, Edward McTamaney, Frank Golden, Harry Olmsted, William Fosbender, and Harry McClure; (third row) Neil Green and Bill Sasch.

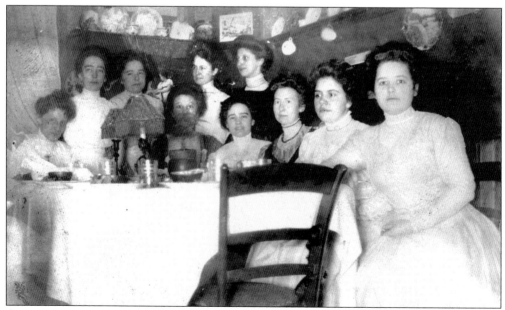

An engagement announcement party was held for Alice Brand in 1909. From left to right are (sitting) Olive Haefele, Grace Hoffert, Alice Brand, Bertha Munch, Anna Munch, and Charlotte Brand; (standing) Emma Munch, Florence Renning, Dot Muhlke, and Edith Munch.

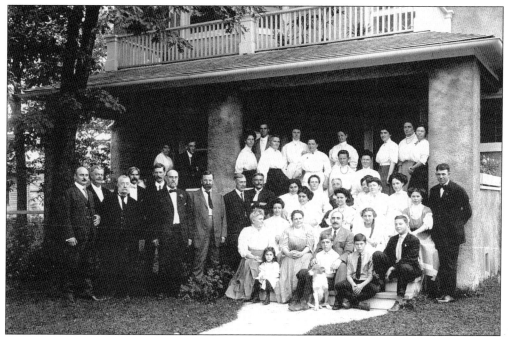

Anthony and Maryetta Renning are seated on the steps of their Second Street home. Surrounded by friends and family, they celebrated 20 years of marriage in 1908. Later an alfresco meal was served at the beach. The celebration extended into the evening with glowing Japanese lanterns. The tall smokestack in the background was from the waterworks pumping station.

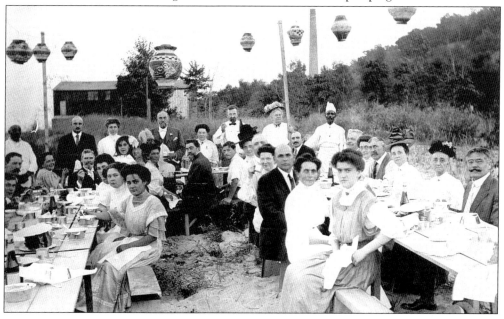

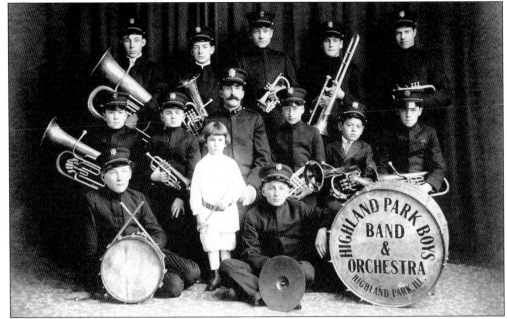

Membership in the Highland Park Boys Band was open to any boy. The band practiced regularly in the Elm Place School auditorium and held semimonthly concerts. Pictured in November 1913 are, from left to right, (first row) Raymond Unbehaun, mascot Marvin Florent, and Fred Gieser; (second row) Harold Geminer, Veran Florent, conductor Francis Florent, Raymond Seiffert, Edwin Nakatani, and John Peterson; (third row) Cyrus Dever, Leonard Friebele, George Hill, Willie Gallagher, and Gervase L. Brown.

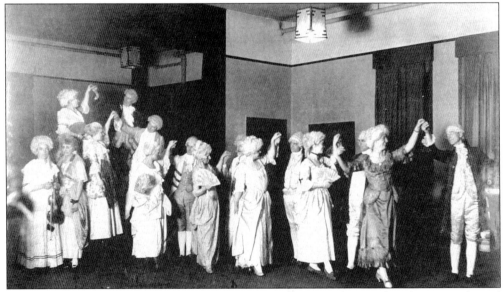

The Ravinia Village House opened on November 22, 1913, as a gathering place for civic and social events. It was the scene of this Colonial costume ball. From left to right are Edna Wilder, Estelle R. Wicks, Dorothy S. Hammond, Evelyn Taylor, Joseph F. Leaming, unidentified, Madelene Woodruff, unidentified, Winifred Miles, Frank Peyraud, Emily Barackman, unidentified, Marjorie Leaming, Harry Barackman, Adelaide Keller, and Orrin Keller.

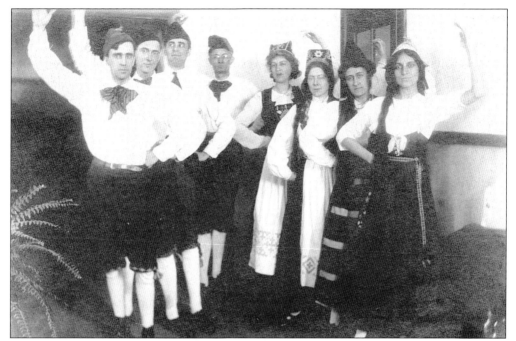

Ravinia residents also performed folk dances at the Ravinia Village House. From left to right are George Fairweather, George W. Carr, Frank R. Bott, Robert R. Grieg, ? Darby, Emily McNeil, Mabel Fairweather, and Alice Bott.

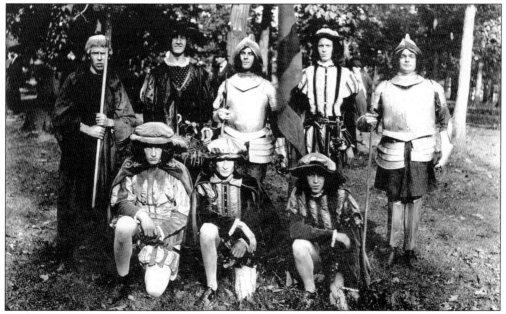

The park district acquired Patrick Sheahan's woods in early 1920 and held a pilgrims pageant there on October 16 to celebrate its opening. The Young Men's Club performed the "Columbus Episode" with Calvin Aynsley in the title role. From left to right are (kneeling) Oscar Stuenkel, Homer V. Scott, and Stanley Carr; (standing) John Mooney, Calvin Aynsley, Osborne Hjelte, Arthur Olson, and Harry Eichler. The woods were named Sunset Woods Park.

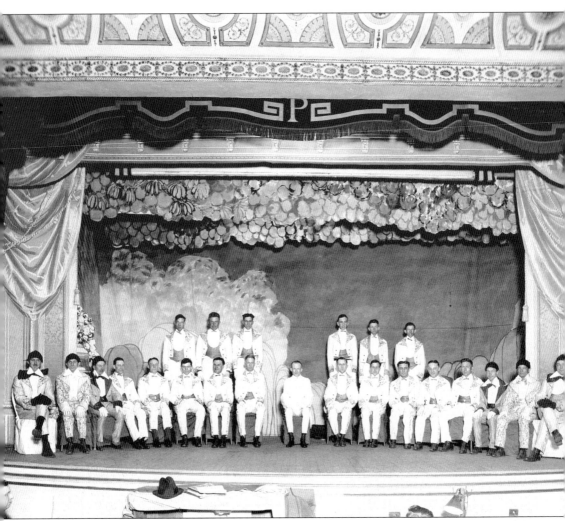

William Pearl opened the Pearl theater on July 5, 1917, for moving pictures and stage performances. In 1920, the Young Men's Club presented a musical there. From left to right are (sitting) Fred Gallagher, Clifford Moran, Raymond H. Cutsler, James Duffy, Jack Bell, William Mooney, Osborne Hjelte, Arthur Olson, Homer V. Scott, Francis P. Rohr, Stanley Carr, Fred Gieser, Millard W. Schreiner, John Peters, Harold Carr, Theodore Arnswold, and Harry Eichler; (standing) Ty Weber, Oscar Stuenkel, Dwight Gibson, Vincent Schreurs, Ervin Clow, and John Witten. Pearl also owned the Alcyon theater, which opened in 1924.

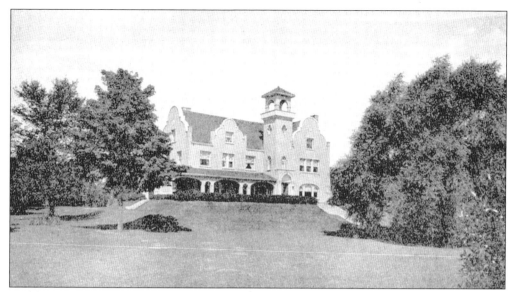

Highland Park retained its rural charm into the new century and continued to attract Chicago businessmen seeking country retreats. Built in 1900, Miralago, the mission-style home of George P. Everhart, was designed by Franklin P. Burnham and occupied a prominent lakefront location at the corner of Sheridan Road and Walker Avenue. After Everhart's death in 1916, it was sold to William M. Wright, president of Calumet Baking Powder Company.

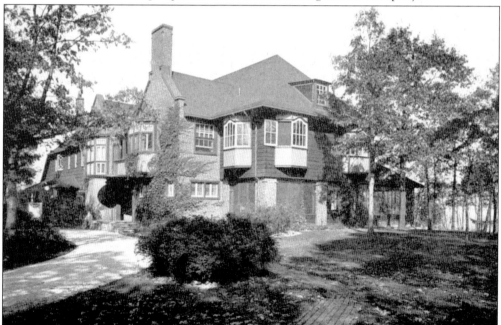

Frank R. McMullin's Ravinia home, House in the Wood, was located on Roger Williams Avenue at the lakefront and constructed in 1900 from a design by Hugh M. G. Garden. McMullin's wife, Jessica, was an enthusiastic horsewoman, and the 12.5-acre estate included a large stable. In 1911, Julius Rosenwald, president of Sears, Roebuck and Company, purchased the estate for $125,000, remodeled the house, and hired Jens Jensen to landscape the property. The house was demolished in 1936.

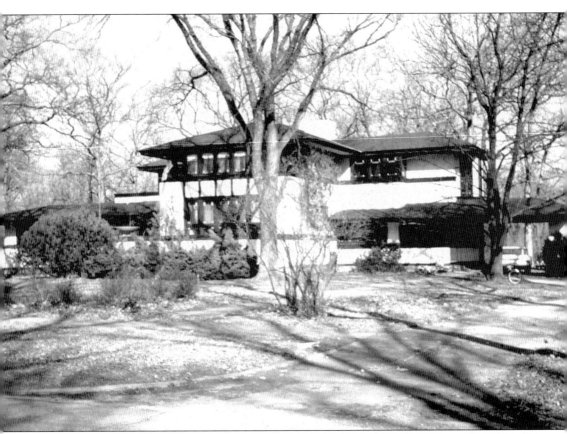

The Ward W. Willits home was designed by Frank Lloyd Wright and constructed in 1902–1903. Wright conceived the idea for the design a year earlier in a plan for a "Home in a Prairie Town." The Willits house was the first to embody many of the prairie-style design elements that are associated with Wright, but construction of the house was not without its frustrations for the impatient Willits. The frequent construction delays and Wright's unresponsiveness to over 50 letters caused Willits to consult instead with Walter Burley Griffin, a 25-year-old architect in Wright's firm, to expedite the work. Willits was a meticulous, knowledgeable client who involved himself in every detail of the project. He made a number of changes to the design and materials and worked directly with the contractors to see that they were implemented. Highland Park resident Fred Clow had the contract for carpentry, masonry, and plastering work.

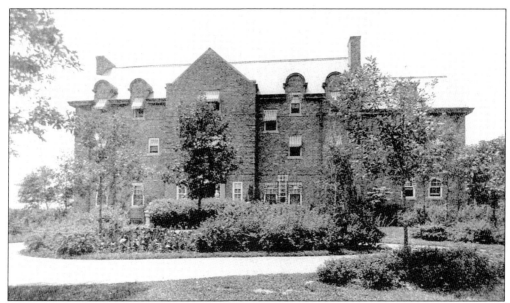

Curtis N. Kimball purchased his 80-acre estate on Green Bay Road around 1905, the year he became president of Kimball Piano Company. It was one of the few large estates west of Green Bay Road in Highland Park. His English country home, Ridgewood, was designed by William A. Otis. A notable feature of the interior was a large organ located on the main stair landing. The east facade presented a plain surface and unadorned entrance. To the west, screened porches opened onto a terraced lawn with extended views across the Skokie valley. A 1929 biographical sketch noted, "With the exception of his business, his greatest pride perhaps is in his north shore estate, its beautiful grounds landscaped with trees, shrubs and flowers . . . he knows no greater pleasure than the horticultural development of this estate." Ridgewood was demolished in 1941.

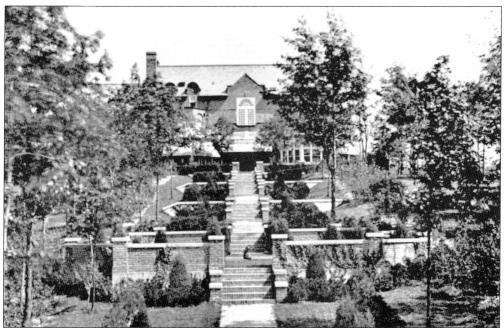

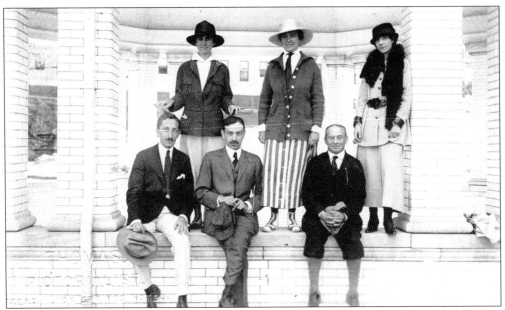

The Colonial Revival home of Robert Centennial Schaffner (born on July 6, 1876) was designed by popular country house architect Howard Van Doren Shaw and built in 1909 on Ravine Drive at the lakefront. Its symmetrical facade was flanked by screened living and sleeping porches. Schaffner was president of A.G. Becker and Company, investment bankers. He is seated at the center front in a photograph taken at the French Lick Springs Hotel in French Lick, Indiana. His wife, Frances, is at the upper right. The nine-and-a-half-acre estate was purchased for $320,000 by the park district in 1970.

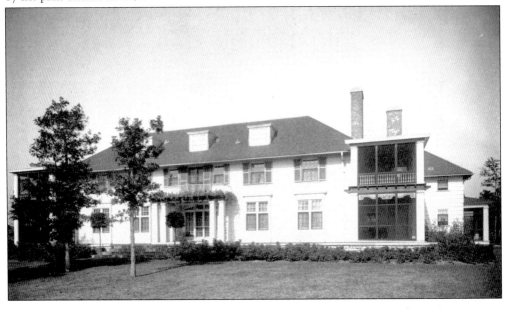

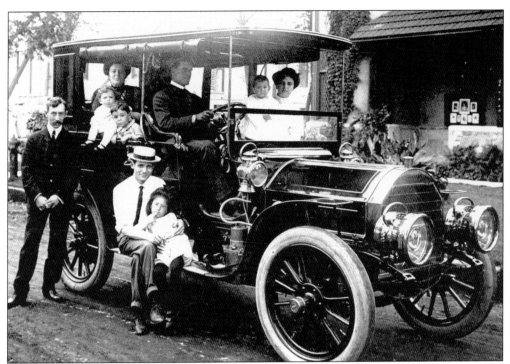

The Mandel home was designed by James Gamble Rogers and constructed in 1900 for Fred H. Page, Frank R. McMullin's brother-in-law. It was purchased by Edwin Mandel in 1913, the year he became president of Mandel Brothers. Edwin was the son of Emanuel Mandel, one of the founders of Mandel Brothers department store. The property comprised eight and a half acres on Roger Williams Avenue at the lakefront. Edwin is pictured on the running board of a Pierce Arrow automobile with niece Mildred. His sister Rose and her son Albert are in the front seat. Rose's husband, Albert S. Louer, is standing. Carrie Mandel and her sons Richard and Frank are in the back seat.

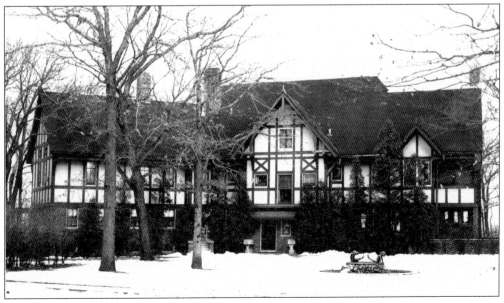

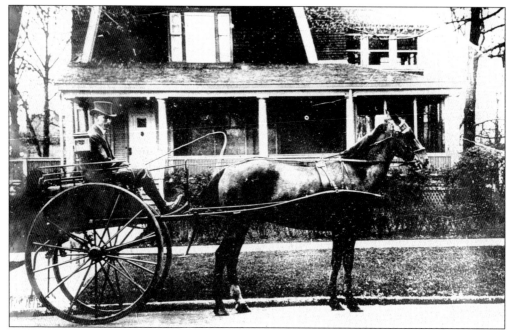

Robert Dixon Sr., coachman from 1910 through 1916 for Bowman Dairy founder Dr. Comfort Peck, was photographed on March 17, 1913, at Peck's Sheridan Road home. Peck was an early sponsor of Ravinia Park and a donor during the Save Ravinia fund-raising drive in 1911.

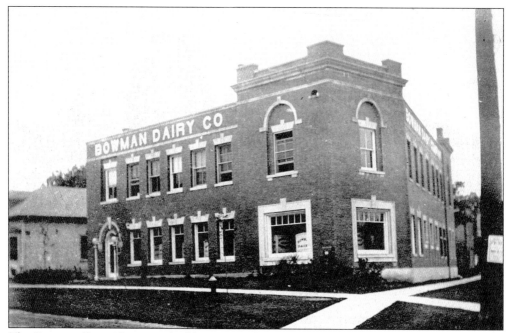

The Bowman Dairy Company building was constructed in 1915 at the corner of Vine Avenue and Green Bay Road on the former site of the Zahnle Dairy. In 1913, Peck had purchased two Highland Park dairies, one owned by William J. and George J. Schmidt and the other by Frank G. Zahnle.

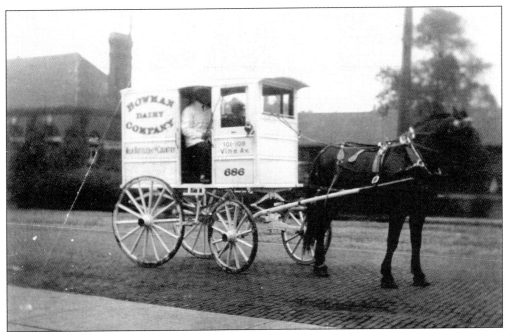

Bowman Dairy Company delivery wagons supplied fresh milk to Highland Park customers. Bowman's advertisements claimed that the company entered the dairy business in Highland Park "by popular request" because a number of its Chicago customers were summer residents and wanted only Bowman milk.

Oscar Larson (left) and Barney Stevens occupy the front seat, and Enoch Nelson (left) and John (Jack) Sheahen, city marshal, are in the back seat at the automobile races at Elgin around 1911. Crowds were thrilled by this new spectator sport. Drivers in caps and goggles "burned" the track and its unbanked turns in open automobiles at speeds approaching 70 miles per hour.

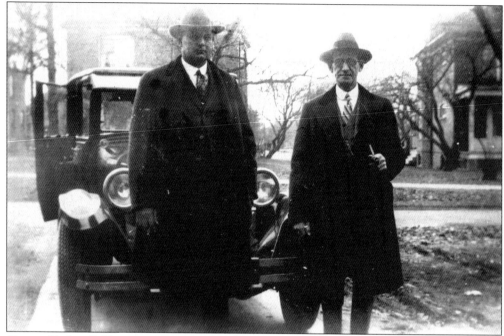

George Tucker (left) came to Highland Park in 1895. After working with his brother Fred for several years, he purchased the Ravinia Grocery and Meat Market in 1909. His half-brother Harry Clow is on the right.

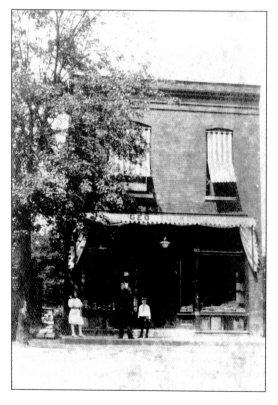

George Tucker's Ravinia Grocery and Meat Market was located on Roger Williams Avenue and was the only store in Ravinia for years. George operated the store until 1921. He is seen with son George Lloyd and daughter Lillian in this c. 1910 photograph.

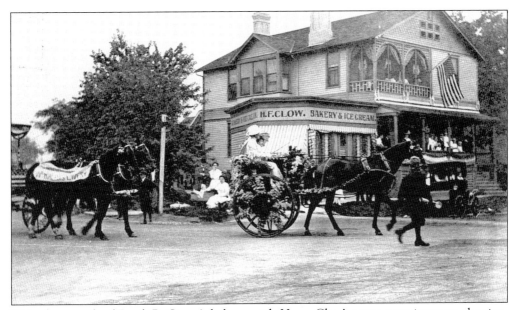

This photograph of Frank B. Green's bakery, with Harry Clow's name prominent on the sign, was taken during a Highland Park Day celebration. Clow worked as a baker with Green before opening the Royal Blue grocery store at Green Bay Road and Second Street.

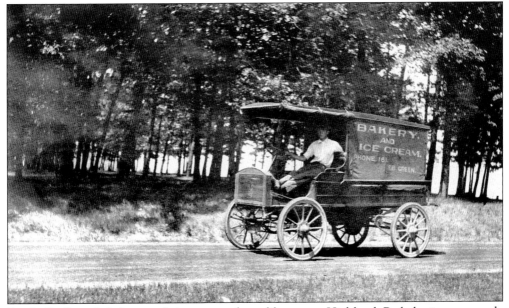

Frank B. Green's bakery and ice-cream shop, like many Highland Park businesses, made deliveries to its customers. The business was taken over by Frank's son, Lester, and continued for many years as Frank's Ice Cream.

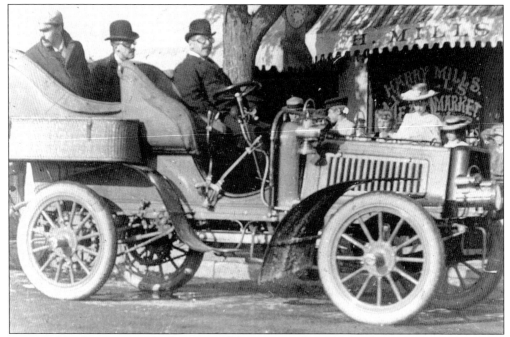

Lewis O. Van Riper sits in the front seat of this c. 1902 photograph taken on St. Johns Avenue. Van Riper came to Highland Park in 1892 and is credited with owning Highland Park's first automobile agency. He also served as an alderman. The goggles were not necessary for driving in Highland Park; the speed limit was eight miles per hour.

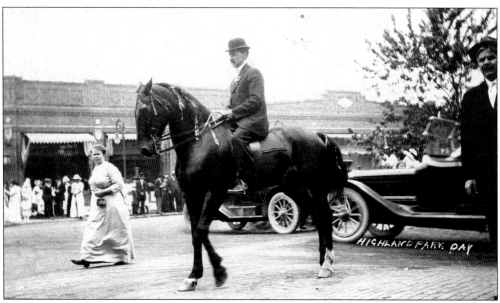

Leo Haak came to Highland Park in 1904. He owned the Palace Cash Meat Market and was one of the organizers of the Highland Park Business Men's Association. Beginning in 1910, the association sponsored the annual Highland Park Day celebration.

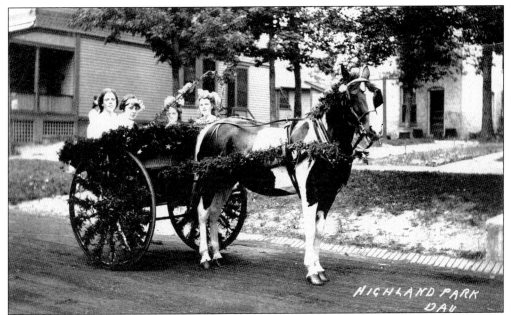

Like the early Children's Day celebrations, Highland Park Day featured a parade with decorated floats. Martin Ringdahl's livery supplied this pony cart occupied by, from left to right, Lillian Ewart, Anna Ringdahl, Alice Duffy, and Edith Ringdahl. Central Avenue was a macadamized road with brick gutters when this photograph was taken around 1910.

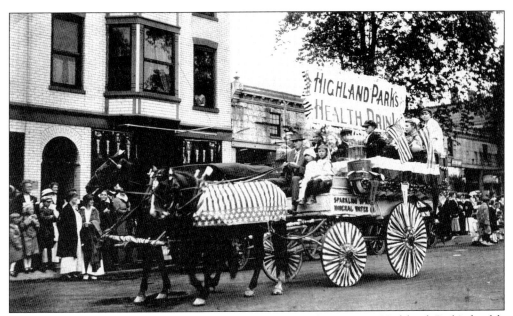

Arthur Tillman advertised his Sparkling Spring Mineral Water as Highland Park's health drink in the 1910 Highland Park Day parade. His business started in the late 1890s when he supplied drinking water to contractors building the Exmoor Country Club. Tillman guaranteed clean water at a time when outbreaks of typhoid fever from contaminated drinking water were still common.

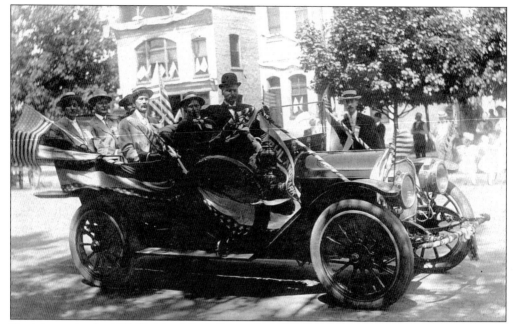

Participants in the 1911 Highland Park Day included Fred Schumacher, owner of Schumacher's Drug Store, in the center seat, David M. Erskine Jr. at right in the front seat, and Charles Warren, owner of a dry goods store (later Garnett's), standing.

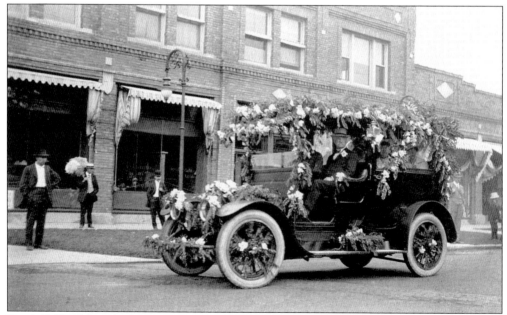

Frank P. Hawkins, the first mayor of Highland Park, was photographed at the 1913 Highland Park Day celebration during his second term as mayor. In 1868, Hawkins and the Highland Park Building Company scheduled the city's first parade and provided a free train from Chicago to attract real estate buyers.

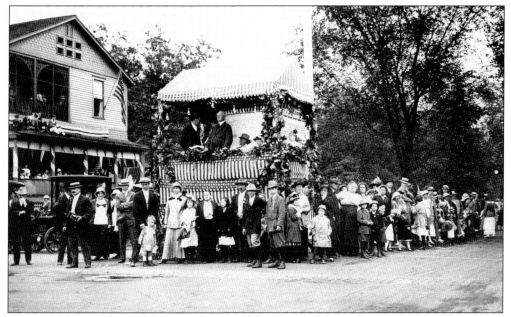

Mayor Samuel M. Hastings occupies the reviewing stand at Central Avenue and Sheridan Road during the 1915 Highland Park Day celebration. Hastings organized the Computing Sale Company, which, in 1911, became one of three divisions of IBM. He was mayor of Highland Park from 1915 to 1928.

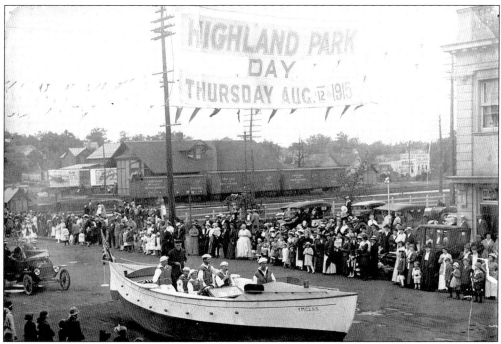

In 1915, the Young Men's Club Life Saving Service had the following members: captain Lyle Gourley, John Swanson, Arthur McCaffrey, Allan Flinn, Edwin Maechtle, Harold Schmidt, and William Royer. The Chicago and Milwaukee Railroad freight station, in the center background, was burned on April 26, 1959, as part of a fire department training exercise.

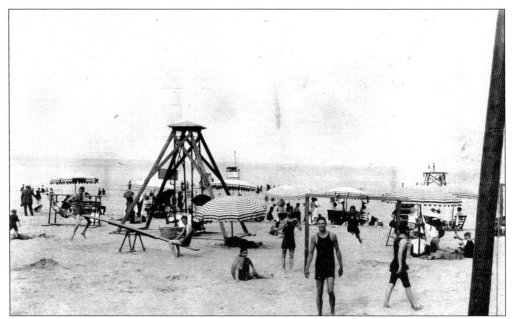

When this photograph was taken in August 1915, the beach provided a variety of playground amusements. A 1916 inventory included three teeters, a slide, a bathing house with 52 lockers, 10 parasols, 24 benches, a diving platform, and a raft with a slide. The beach had been under the jurisdiction of the Ossoli Club since 1911. The club oversaw maintenance of equipment and facilities and provided a swimming instructor.

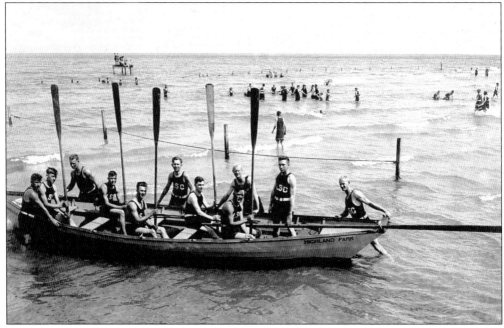

The Young Men's Club Life Saving Service crew in 1921 is, from left to right, Raymond H. Cutsler, Fredrich Siljestrom, George Bolan, Stanley Carr, Osborne Hjelte, Francis P. Rohr, Arthur McCaffrey, Roland Brand, John Gallagher, John Peters, and Fred Gallagher.

The new brick pavement of Green Bay Road was dedicated on November 16, 1916, with a ribbon-cutting ceremony. The pavement extended from Central Avenue south to the city limits. City officials are, from left to right, Fritz Bahr, commissioner; Samuel M. Hastings, mayor; George Huber, commissioner; Charles Russell, engineer; Ward W. Willits, commissioner; Edward A. Warren, city clerk; and William L. Meyers, marshal. Dorothy Evans had the honor of cutting the ribbon.

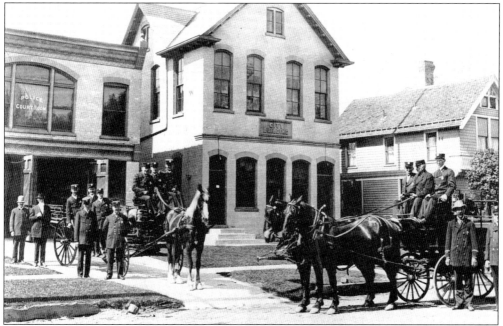

In 1902, a fire station with an upstairs police courtroom was built west of the city building. The city building was remodeled at the same time with a gable roof. The volunteer fire department, pictured in 1908, was equipped with a ladder wagon (left) and hose wagon. Fire Marshal Paul Gieser is at the right in the Stetson hat.

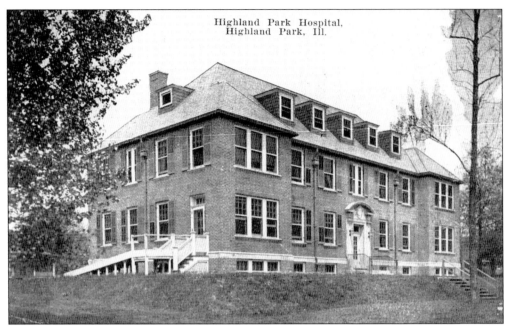

Highland Park Hospital was designed by Roy E. Pingrey and opened on July 14, 1918. The hospital had a capacity of 18 beds and six cribs. In 1917, nearly $100,000 was subscribed by about 700 individuals in gifts ranging from $5 to $5,000 to fund the building and equipment. An addition in 1924 increased the capacity to 55 beds and 18 cribs. The cost of a private room was $6 to $12 per day. The operating room was located in a sun-lit room on the second floor and featured the latest medical technology. The operating room fee was $15 to $20, which included the fee for an anesthetic.

City of Highland Park
Health Bulletin
October 19, 1918

QUARANTINE REGULATIONS which have been in force during the recent epidemic are hereby RAISED so far as SCHOOLS and CHURCHES are affected. Elementary and High Schools will open Monday morning, Oct. 21st; Churches Oct. 20th.

Theatres, amusements and social gatherings are for the present prohibited.

Regulations on Admitting Pupils to School

1. Pupils who have suffered with influenza will not be admitted to school until they have been out of bed and free from all evidences of the disease, such as coughing, sneezing, etc., FOR ONE WEEK.

2. No pupil will be admitted who coughs, sneezes or shows other evidences of a cold. Such pupils, if they do come, will be promptly sent home.

3. Teachers will be required to question each child and record the history of any illness in the homes during the period of the epidemic.

4. An inspector will be present at each school on Monday morning to see that these regulations and precautions are enforced. **BOARD OF HEALTH.**

The hospital could not handle the number of influenza cases in Highland Park, estimated to be around 600 during the 1918 epidemic. The clubhouse at Exmoor Country Club was converted into a hospital where 125 patients were treated. Members of the Highland Park Woman's Club and the Ossoli Club served as nurses. There were approximately 50 influenza deaths in Highland Park and Highwood during the epidemic, 25 during the first week of October. For years afterward, any sign of illness resulted in a flu scare in the shaken community. The bulletin of quarantine regulations was written by Dr. Frank M. Ingalls, Dr. Lloyd Bergen, Jesse Lowe Smith, and Richard L. Sandwick.

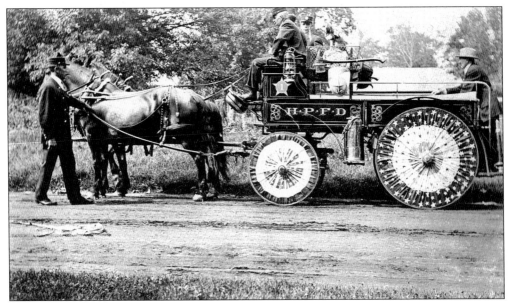

The horse-drawn fire wagon is decorated for the 1911 Highland Park Day celebration. From left to right are Gus Leffert, Andy Root, Fred Lindstrom, and Paul Gieser, fire marshal. Prior to 1913, volunteers with horse teams were used, and the first man to get his team hitched to the apparatus was paid $5.

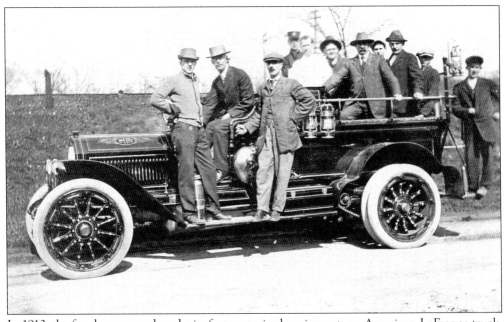

In 1913, the fire department bought its first motorized equipment, an American LaFrance truck, for $5,500. From left to right are Orville St. Peter; John Oliver, mayor; Adolph Gieser, fire marshal; Fred Lindstrom, driver; Solomon A. St. Peter; George Turtle; Paul Gieser; and four unidentified volunteers. In 1917, the fire marshal earned $10 a month. Eleven volunteer firemen each earned $5 a month plus $1 for each fire.

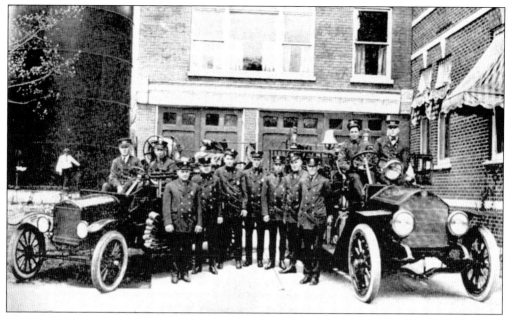

The Highland Park Fire Department in 1922 was staffed by, from left to right, Assistant Chief William Cummings, Joe Sullivan, Andrew Peterson, Paul L. Udell, John C. Fay, George Clark, Raymond Oetzel, Lloyd Sheahen, Lt. William Fosbender, driver Winnie Glader, and Chief Edward C. Hoskins. A fireman on the ladder wagon rang a large bell to warn pedestrians and other vehicles to clear the road for the fire truck.

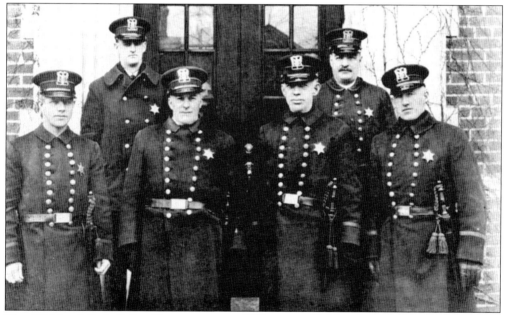

The Highland Park Police Department in 1923 was staffed by, from left to right, Charles Rafferty; Edward Moroney, marshal; James Lindsay; John Sullivan; John (Jack) Sheahen, assistant marshal; and Edward Borkert. In April 1918, an automobile was purchased for the police department. It was predicted that "this improvement will greatly increase the efficiency of the department for answering calls, patrolling the city, and caring for emergency cases."

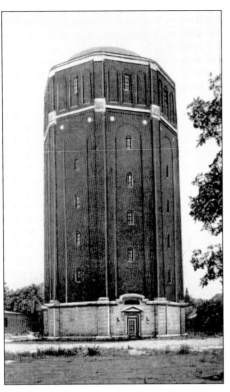

In 1929, a steel water tank replaced the old standpipe. It was built by the Chicago Bridge and Iron Works, standing 130 feet tall with a capacity of 500,000 gallons. To prevent the unattractive steel tank from marring the skyline, it was enclosed in a unique brick and stone structure designed by Arthur S. Coffin.

Shortly after this photograph was taken, Deerfield Road, shown looking west from McGovern Avenue, was widened and paved. In 1924, more than six square miles were annexed to Highland Park. The Chicago North Shore and Milwaukee Railroad constructed the Skokie valley route. Highland Park Gardens, Forest Ridge, and Sherwood Forest subdivisions were among several developments on the west side. Highland Park would emerge from the 1920s as a vigorous modern suburb.

Four

PORTRAITS

Thomas McCraren was born in County Monaghan, Ireland, on May 20, 1822, and married Bridget Mooney there. In March 1840, they sailed to Quebec, Canada, then traveled to Burlington, Vermont, where they lived until 1845 when they came to Chicago. They had two children, Annie and Ellen. Bridget died in 1848. After living in Chicago for three years, Thomas purchased 80 acres west of the Skokie River on June 1, 1848. He built a log cabin home and helped construct St. Mary's in the Woods church. He also helped build Deerfield Road. Thomas married twice more and had eight additional children. He eventually owned 185 acres, much of it originally heavily wooded. A portion of the farm was sold to the Chicago North Shore and Milwaukee Railroad for the Skokie valley route. Most of the remaining land was sold during the 1920s for the Highland Park Gardens, Sunset Woods, and Briergate subdivisions.

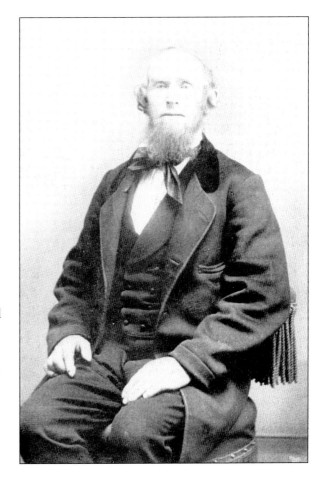

No one did more for Highland Park's development than Frank P. Hawkins. At 27 years of age, he was the youngest member of the Highland Park Building Company. He became the company's manager and general agent, supervised the sale of company property and promoted the construction of commercial buildings, Port Clinton Avenue School, Highland Hall, and early churches, often on land donated by the building company. He was the city's first mayor and served a second term in 1913. He published the community's first newspaper, the monthly *Highland Park News*, from April 1874 through May 1875. He was one of the originators and promoters of Sheridan Road, obtaining the right-of-way through privately held property to extend the road through Highland Park south to Glencoe. At his funeral in 1935, Rev. Louis W. Sherwin eulogized, "What vision and constructive genius he expressed in his activity and what love of this place he chose as his home he richly expressed in the planning and far-sighted building he did. His fidelity and wisdom and grace have touched this community in a way that will abide through many, many years."

William W. Boyington was born in Maine in 1818 and came to Chicago in 1853. His first home was destroyed by the 1871 Chicago fire and a second home burned down in 1874, after which he came to Highland Park. Despite the demands of a prolific architectural career, Boyington was active in the civic and social affairs of the community. He served as mayor for two terms, from 1875 to 1877. As mayor, he promoted water purification, the prohibition of liquor sales, and more adequate and effective fire protection. His design of the Highland Park House hotel included the installation of a mercurial fire alarm with electric bell attachments in every room. At his urging, a railroad viaduct was constructed at Laurel Avenue. He was responsible for many buildings in early Highland Park, including the Presbyterian church, Fairview School, the Northwestern Military Academy building, the Gray Electric Company building, and numerous private residences.

Elisha Gray came to Highland Park in 1871 and lived in a home on Hazel Avenue. He had an artesian well on his property that supplied water for the neighborhood and filled an artificial pond that was a popular skating rink in winter. With Anson Stager, head of the Union Signal Corps during the Civil War, and telegrapher Enos Barton, Gray organized the Western Electric Company in 1872. A devout Presbyterian, Gray served as a trustee of the church from 1873 to 1884 and as an elder from 1884 until his death in 1901. After the financial panic of 1873, when the church was in debt, Gray gave generously to help pay debts from construction of the church building. Gray gave the first public exhibition of the telephone at the church in December 1874. Although he lost the patent battle for the invention to Alexander Graham Bell, Gray holds numerous patents for other inventions, including the stock printer or ticker, hotel and elevator annunciators, burglar and fire alarms, and the telautograph, an early version of the fax machine. He constructed the imposing Gray Electric Building as a manufacturing plant for his inventions.

Archibald W. Fletcher was born in Ontario, Canada, in 1839. He came to Highland Park in 1883 and opened a coal yard, adding a lumber business that specialized in piers and breakwaters a year later. Fletcher was mayor from 1893 to 1895 and advocated construction of the waterworks. He served as postmaster from 1900 to 1912 and was on the board of supervisors of Lake County. In 1889, he erected a three-story brick building on Central Avenue and in 1908 added an adjacent building that served as a post office.

Andrew Bock was born in Germany in 1838 and came to Chicago in 1868. Two years later he moved to Highland Park and was appointed its first fire chief in 1889. In 1891, he was the architect and builder of the Evangelical Lutheran Zions Church. That same year he established a general store on Central Avenue, which was managed by his wife, Mina, and later by his son, George.

Rev. Peter Clark Wolcott came to Highland Park in 1892 as rector of Trinity Church. He served on the library board for 30 years from 1893 and on the high school board for 18 years from 1898. Following his 1879 ordination, he worked among the Oglala Sioux at the Pine Ridge Agency in South Dakota for several years. After retiring in 1926, Wolcott wrote a history of Trinity Church, published by the Lakeside Press.

David M. Erskine Jr. came to Highland Park in 1875 to establish an insurance and real estate business. Born in Antigua, West Indies, in 1855, he served as justice of the peace, alderman, and, at age 36, as the youngest mayor of Highland Park (1891–1893). He published a monthly business and advertising journal from July 1883 to June 1884 and opened Highland Park's first bank in 1899. He was an active member in the businessmen's association.

In 1886, Frederick W. Cushing moved to Highland Park from Merrill, Wisconsin, where he had married Cassia M. Scott, the daughter of lumber king Thomas B. Scott. Cushing was employed by Elisha Gray. In 1890, Cushing was one of the founders of the Highland Park Electric Light Company and in 1892 was one of the incorporators of the Gray International Telegraph Company. Cushing constructed Hotel Moraine in 1900 and operated it until the late 1930s. He served as president of the Highland Park State Bank and hired architect Ernest A. Mayo to design the three-story bank building constructed on St. Johns Avenue in 1905. He served on the first commission of the Highland Park East Park District when it was created on May 28, 1909, and was president of the consolidated district when the west side of Highland Park was added in 1919. He also served on the city plan commission.

Ward W. Willits came to Highland Park in 1903 to occupy the residence designed for him by Frank Lloyd Wright. Born in New Boston, Illinois, in 1859, at the age of 16 he became a clerk in the law firm of Isham and Lincoln, of which Robert Todd Lincoln was a partner. Willits joined Adams and Westlake as a stenographer in 1879 and rose to the presidency in 1904. He married Cecelia Mary Berry in 1897 and named his first son John McGregor after his employer, John McGregor Adams. After moving to Highland Park, Willits joined the Exmoor Country Club and became its vice president in 1906. Willits served on the first commission of the Highland Park East Park District in 1909 and was its president four years later. He also was a school board member for District 108. In 1915, when Highland Park changed to the commission form of government, Willits was elected as a commissioner. Willits was one of six major donors who contributed $5,000 each to the 1911 Save Ravinia campaign when the park was in financial difficulty.

Jesse Lowe Smith came to Highland Park in September 1902 as principal of Elm Place School and superintendent of District 107. He was an inspiring educator who introduced innovative teaching methods. Among many civic contributions, he helped organize a Boy Scout troop in Highland Park, was a director of the North Shore Art League, served for 15 years on the library board, helped establish a historical society, and worked on the board of health during the influenza epidemic. His botanical knowledge made him a sought-after speaker at garden clubs and led to his appointment to the City Beautiful commission in 1915 and later to the Tree and Parkway commission. In the 1930s, he helped coordinate community work projects for Illinois Emergency Relief workers. He was a member of the Chicago Geographic Society (director and president), the Illinois Audubon Society (director and vice president), and a charter member of Friends of Our Native Landscape. His untimely death in April 1934 was mourned throughout the community. A section of the memorial garden located between the library and city hall is dedicated to his memory.

Richard L. Sandwick came to Highland Park in September 1903 as principal of the high school, a position he held for 35 years. In a 1935 interview, he listed his most worthwhile enterprises at the high school as the establishment of student government (1907), the careful selection of teachers from a national field of applicants, and the creation of a teacher advisor system where each teacher acted as an advisor to 25–30 students. In 1925, he established a vocational trades department and hired Walter Durbahn to head it. His ideas for secondary schools were adopted throughout the country: a commercial department, a guidance system through teacher advisors, and student government in the hands of student councilors. He retired in 1937. Two years after his retirement, Sandwick Hall at the high school was named in his honor. The building was designed by Durbahn and constructed by students.

Jens Jensen came to Highland Park around 1911 and established a home and studio on Dean Avenue in Ravinia. Already a noted landscape gardener for his work with Chicago's West Park system, Jensen had developed a clientele among prominent North Shore residents. His Highland Park commissions included the estates of Julius Rosenwald, George Pick, Martin Insull, A. G. Becker, Harold M. Florsheim, and Adolph J. Lichstern. He created the landscape designs for the Northmoor Country Club, Central Park, the park at Roger Williams and St. John's Avenue, and for the Ravinia, Lincoln, Green Bay, and Dean Avenue schools. In 1928, the Tree and Parkway commission was established with Jensen, Jesse Lowe Smith, and William G. Tennant as commissioners. Their task was to develop a landscape plan and oversee planting for all public parkways in Highland Park and Ravinia. Jensen formed Friends of Our Native Landscape, a group that advocated landscape preservation and helped establish several state parks. He advised the Highland Park East Park District board in its selection of park sites. Like his friend Jesse Lowe Smith, a section of the memorial garden located between the library and city hall is dedicated to his memory.

Edith McGregor Adams, noted philanthropist, was a major donor in the effort to establish Highland Park Hospital and after her death in 1925 left $100,000 for its continued operation. She gave $5,000 to the 1911 Save Ravinia campaign and was a benefactor to the YWCA, Lake Bluff Orphanage, and Arden Shore Association. She served on the board of the Highland Park Improvement Association and, with Curtis N. Kimball and John F. L. Curtis, on the business district lighting committee.

Dumaresq Spencer was chosen by Highland Park's legionnaires as their namesake for Post 145, founded on September 15, 1919. After graduating from Yale in 1917, he went to France where he joined the Lafayette Escadrille and later transferred to the Franco-American Flying Squadron. He was killed on January 27, 1918, while returning from air patrol duty over German lines. Dumaresq's brother E. Winfield Spencer was the first husband of Betsy Wallis Warfield (later the Duchess of Windsor).

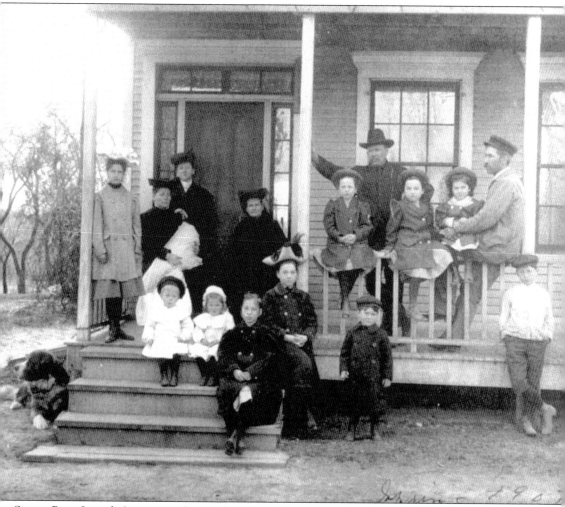

Simon Peter Loesch (sitting on the porch rail at right) was born in Highland Park in 1871, the grandson of one of Highland Park's earliest settlers, Andre Xavier Loesch. A portion of his family's farm was sold to the Chicago and Milwaukee Railroad and the Northmoor Country Club. Loesch worked for Elisha Gray, then the Chicago and Northwestern Railroad, before becoming city marshal in 1898 and later merchant's policeman until his retirement in 1943. In a 1907 family portrait are, from left to right, (on the porch) Lil Dietrich, Peter's sister Mary Dietrich (holding her daughter Catherine), wife Sarah Loesch, mother-in-law Sabina Duggan, Alice Loesch, brother-in-law George Dietrich, Catherine Loesch, Julia Loesch, and Simon Peter Loesch; (on the steps) Lawrence and Florence Dietrich, Vera Thompford (a neighbor), and Margaret Loesch; (standing in front of the porch) Louis Dietrich and Leo Loesch.

BIBLIOGRAPHY

Arenberg, Henry X., ed. *Highland Park: All American City.* Highland Park, IL: Highland Park Bicentennial Commission, 1976.

Benjamin, Susan, ed. *An Architectural Album: Chicago's North Shore.* Evanston, IL: Junior League of Evanston, 1991.

Chamberlin, Everett. *Chicago and Its Suburbs.* Chicago: T. A. Hungerford and Company, 1874.

Ebner, Michael. *Creating Chicago's North Shore.* Chicago: University of Chicago Press, 1988.

Eglit, Howard, ed. *Founded on Faith: Highland Park's Historic Houses of Worship.* Highland Park, IL: Highland Park Historic Preservation Commission, 1998.

Goldstein, Marsha, ed. *Highland Park by Foot or Frame.* Highland Park, IL: Highland Park Landmark Preservation Committee, 1980.

Halsey, John J. *A History of Lake County, Illinois.* Philadelphia: R. S. Bates, 1912.

Highland Park: American Suburb at Its Best. Highland Park, IL: Highland Park Landmark Preservation Committee, 1982.

Highland Park: The First Hundred Years. Highland Park, IL: c. 1969.

"Highland Park's Diamond Jubilee Edition 1869–1944." *Highland Park News.* March 9, 1944.

Meiners, Evelyn Peterson. *The Origin and Early History of Highland Park, Illinois.* Evanston, IL: Self-published, 1942.

The Past and Present of Lake County, Illinois. Chicago: William Le Baron and Company, 1877.

Portrait and Biographical Album of Lake County Illinois. Chicago: Lake City Publishing Company, 1891.

Sorenson, Martha E. *View from the Tower: A History of Fort Sheridan, Illinois.* Highwood, IL: Tower Enterprises, 1985.

Truax, Evva Egan. *Notes on History of Highland Park, Illinois.* North Shore Chapter, Daughters of the American Revolution, 1920.

Weingartner, Fannia. *Ravinia: The Festival at Its Half Century.* Ravinia, IL: Ravinia Festival Association, 1985.

Wittelle, Marvyn. *Pioneer to Commuter: The Story of Highland Park.* Highland Park, IL: Rotary Club of Highland Park, 1958.

INDEX

Adams, Edith McGregor, 124
Alexander, William Arthur, 35, 40, 41
Alta School, 48
Bahr, Fritz, 72, 107
Baptist church, 21
Beers, Herbert, 84
Bethany Evangelical Church, 30, 31
Birch, Hugh Taylor, 41, 42, 56
Bluff City Electric Railway, 60
Bob O'Link Golf Club, 41
Bock, Andrew, 117
Boyington, William W., 15, 20, 25, 28, 35, 36, 38, 44, 46, 115
Brand, Orson Benjamin, 4, 49, 84
Chicago and Milwaukee Electric Railway, 2, 56, 60, 74
Chicago North Shore and Milwaukee Railroad, 8, 60, 112, 113
city building, 45, 65, 107
Clow, Fred, 38, 94
Coale, Henry K., 24, 42
Cummings, George B., 30, 59
Cushing, Frederick, W., 61, 69, 119
Duffy, John C., 19, 63, 64
Eckstein, Louis, 75
Egan, William C., 36, 41
Elm Place School, 8, 47, 81–84, 90, 121
Erskine, David M., Jr., 57, 63, 64, 79, 104, 118
Exmoor Country Club, 10, 40, 41, 71, 103, 109, 120
Fairview School, 20, 81, 115
fire department, 54, 105, 107, 110, 111
Fletcher, Archibald W., 26, 27, 56, 79, 117
Flinn, Raymond W., 47, 65, 77, 81
Fort Sheridan, 7, 11, 27, 43, 59

Fullerton, Charles W. 39, 41
Gray, Elisha, 28, 46, 116, 119, 125
Hastings, Samuel M., 105, 107
Hawkins, Frank P., 7, 8, 15, 22, 104, 114
Highland Hall, 25, 32, 44, 114
Highland Park Building Company, 7, 8, 15, 16, 18, 22, 25, 29, 35, 73, 104, 114
Highland Park Business Men's Association, 59, 102
Highland Park Club, 40
Highland Park Electric Light Company, 61, 119
Highland Park Hospital, 108, 124
Highland Park Police Department, 111
Highland Park Public Library, 20, 77
Highland Park Woman's Club, 53, 85, 86, 109
high schools, 17, 24, 30, 65, 66, 68, 122
Hotel Moraine, 69–71, 72, 119
Ingalls, Dr. Frank M., 24, 80, 109
Insull, Samuel, 60, 61
Jensen, Jens, 93, 123
Kimball, Curtis N., 2, 95, 124
Larson, Albert, 29, 59, 78, 84
Lincoln School, 20, 81
Mandel, Edwin, 97
Mayo, Ernest A., 69, 73, 119
McCraren, Thomas, 10, 113
McDonald's store, 7, 21, 29, 58, 63, 79
McMullin, Frank R., 74, 93, 97
Millard, Everett L., 40
Millard, Sylvester M., 36
Mooney, John, 56
Moroney, Edward, 47, 65, 88, 111
Moses, Moses, 17
Northmoor Country Club, 13, 123, 125
Northwestern Military Academy, 25, 44, 115

Onwentsia Club, 87
Ossoli Club, 53, 106, 109
park district, 81, 91, 96, 119, 120, 123
Parliament, Samuel, 38, 72
Pingrey, Roy E., 108
Pond, Allen B., 40
Pond, Irving K., 40
Port Clinton Avenue School, 8, 18–20, 29, 47, 114
Presbyterian church, 28, 34, 115
Prior, Percy, 50
Ravinia Park, 2, 42, 74–76, 98
Ravinia Village House, 90, 91
Ringdahl, Martin, 71, 103
Rosenwald, Julius, 93, 123
Sandwick, Richard L., 109, 122
Schaffner, Robert Centennial, 96
Sheahen, John (Jack), 63, 99, 111
Shaw, Howard Van Doren, 96
Shields, James H., 40, 66
Smith, Jesse Lowe, 82, 83, 84, 109, 121, 123
Sparkling Spring Mineral Water, 103
Spencer, Dumaresq, 125
St. Mary's Church, 73
St. Mary's in the Woods, 8, 10, 113
Steers, Jonas, 21, 22
Streeter, Samuel S., 14, 30
telephone exchange, 76
Trinity Church, 73, 118
United Evangelical Church, 52
Van Riper, Lewis O., 72, 85, 102
Wainwright, Jonathan Mayhew, 47
water tank, 112
Weber, Peter J., 74
Willits, Ward W., 94, 107, 120
Wolcott, Rev. Peter Clark, 118
Wood, Robert E., 84
World's Columbian Exposition, 35, 46
Wright, Frank Lloyd, 94, 120

ACROSS AMERICA, PEOPLE ARE DISCOVERING SOMETHING WONDERFUL. THEIR HERITAGE.

Arcadia Publishing is the leading local history publisher in the United States. With more than 3,000 titles in print and hundreds of new titles released every year, Arcadia has extensive specialized experience chronicling the history of communities and celebrating America's hidden stories, bringing to life the people, places, and events from the past. To discover the history of other communities across the nation, please visit:

www.arcadiapublishing.com

Customized search tools allow you to find regional history books about the town where you grew up, the cities where your friends and family live, the town where your parents met, or even that retirement spot you've been dreaming about.